D0536831

DALE CHIHULY

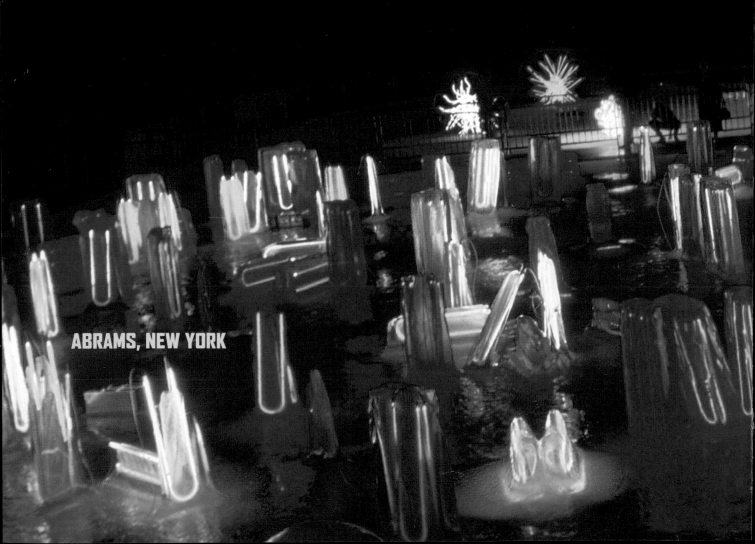

ABRAMS, NEW YORK

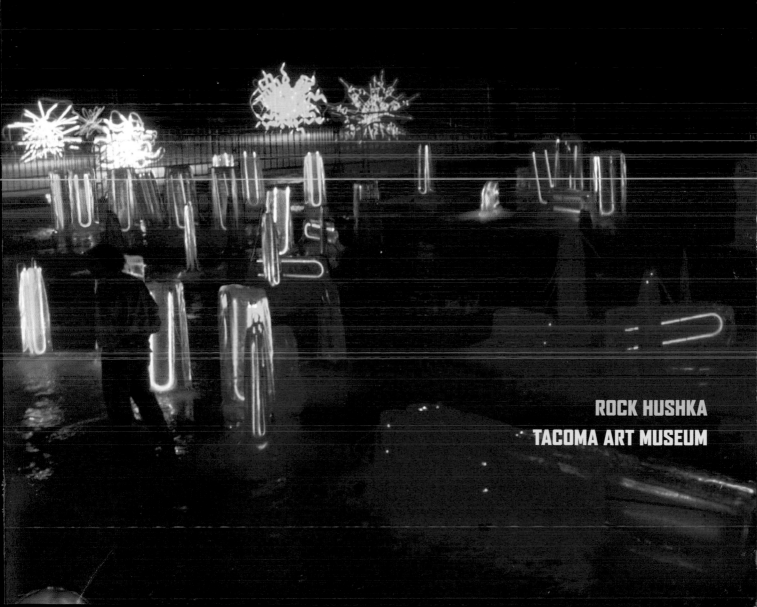

A CELEBRATION

ROCK HUSHKA
TACOMA ART MUSEUM

For my hometown & the people of Tacoma.

love
Chihuly

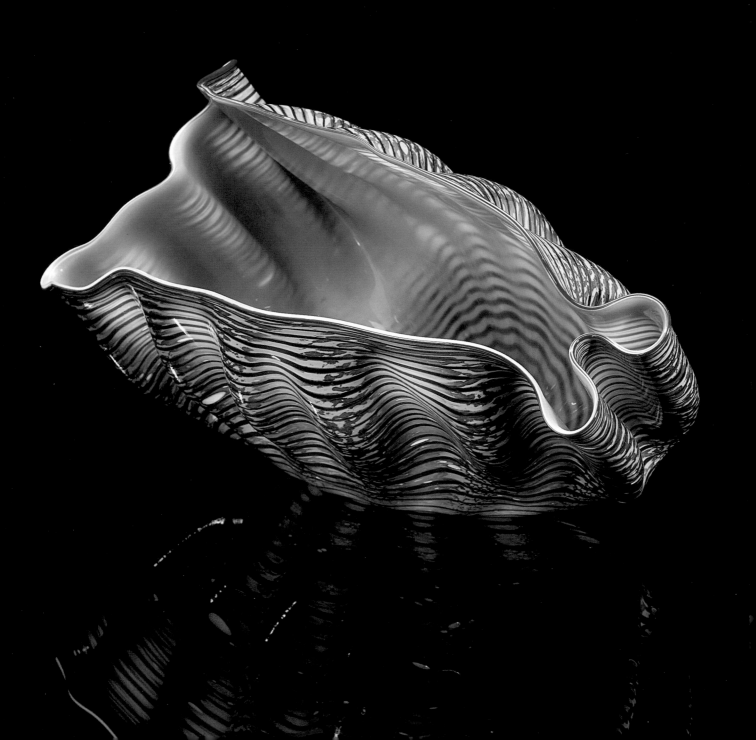

CONTENTS

When you come to Tacoma, you know immediately that you have arrived in Dale Chihuly's hometown. Evidence of his generosity and his love for the city are everywhere—from the historic Union Station, a former train depot now filled with major eye-catching installations, to the spectacular Chihuly Bridge of Glass that serves as a welcome to downtown for pedestrians and motorists alike.

The first question everyone asked me as the new director of Tacoma Art Museum in 2005 was, when I was bringing back *Mille Fiori?* This dazzling installation opened the museum's new Antoine Predock–designed building in 2003. My predecessor, Janeanne Upp, had the brilliant idea of inviting Dale to create something unique to celebrate the museum's first custom-built facility after the museum had lived in repurposed historic structures around town—from an academic tower to a storefront to a bank building—since its start in 1935. The exhibition delighted visitors young and old, and was even extended several weeks prompted by sidewalk picketing that was staged by a trustee, as the story goes.

Early on, I shared with Dale my desire to have him develop a new and memorable installation at the museum, which he did in 2006 with *Ma Chihuly's Floats,* which are on display seasonally in the museum's interior courtyard. To my surprise, Dale and Leslie Jackson Chihuly donated this work, in honor of Dale's mother, to the museum later that same year. Also in 2006, Tacoma Art Museum created a cell-phone walking tour and map of Dale's works in downtown Tacoma's Museum District. We at Tacoma Art Museum are proud to share *Dale Chihuly: A Lifetime of Inspiration* on the occasion of Dale's seventieth birthday. We have developed a long and vital relationship with Dale, beginning with his first museum exhibition in 1971. Successive generations of directors and trustees have supported Dale and nurtured his development, most notably honorary trustee Anne Gould Hauberg, who, with husband John, cofounded the Pilchuck School with Dale in 1971. Since 1987, the largest retrospective collection of his works has been on continuous public view at Tacoma Art Museum. Dale gifted the major pieces to the museum in 1990 in honor of his mother, Viola, his father, George, and his brother, George W. In 2003, the collection was reinstalled in the museum's lobby, again in specially designed wall cases and with four new *Ikebana* works to include recent developments in his career. In the summer of 2010, this collection was installed in a more accessible, open gallery of its own.

In addition to the treasured Dale Chihuly Collection, the museum has also presented *Dale Chihuly: Glass Blowing* in 1981, *Dale Chihuly: Works on Paper* in 1992, and the landmark *Dale Chihuly: Mille Fiore* in 2003. These exhibitions mark important milestones in both

the museum's history and the artist's career. The publication of this book accompanies the museum's exhibition *Dale Chihuly's Northwest*, an expanded installation of Dale's Northwest Room in The Boathouse. Including works from Dale's personal collections with his glass, this installation provides a unique opportunity to experience how the diverse influences of the region have informed his career. This special exhibition completes also the year-long celebration of the museum's seventy-fifth anniversary.

We are grateful to Dale for his many gifts to the City of Tacoma and his great pride in its history. In 1966, while working in the Alaska fisheries, Dale sent a letter to the editor of the *Tacoma News Tribune*

urging preservation of the old City Hall building on Pacific Avenue. From his most recent installation in the W. W. Seymour Botanical Conservatory to the vibrant red *Chinook Chandelier* at the University of Washington Tacoma and the autumn–ivy-inspired *The Chihuly Window* at the University of Puget Sound, to his ongoing support of the Hilltop Artists program, Dale's art and hometown philanthropy have served as inspiration to generations of citizens and visitors to Tacoma. Without his vibrant art and expansive vision, Tacoma would be a very different place.

This publication and exhibition reflect Dale and Leslie Jackson Chihuly's extraordinary generosity and continued support. The museum also acknowledges the gracious assistance of the Chihuly Studio, without which this book would not have been possible. In particular, we are most grateful to Billy O'Neill, Britt Cornett, and Diane Caillier for their unflagging support. At Abrams, it has been a special treat to collaborate with my longtime friend, editor Margaret L. Kaplan, and the talented designer Russell Hassell, who both worked tirelessly to help conceive and create this handsome publication. I am also proud of our own curator Rock Hushka's usual fearlessness and charm in taking on the challenge of trying to capture Dale's creative spirit and love of place. Finally, we salute Dale, the world-renowned and favorite son of Tacoma.

Happy seventieth birthday, Dale! We love you.
Stephanie A. Stebich

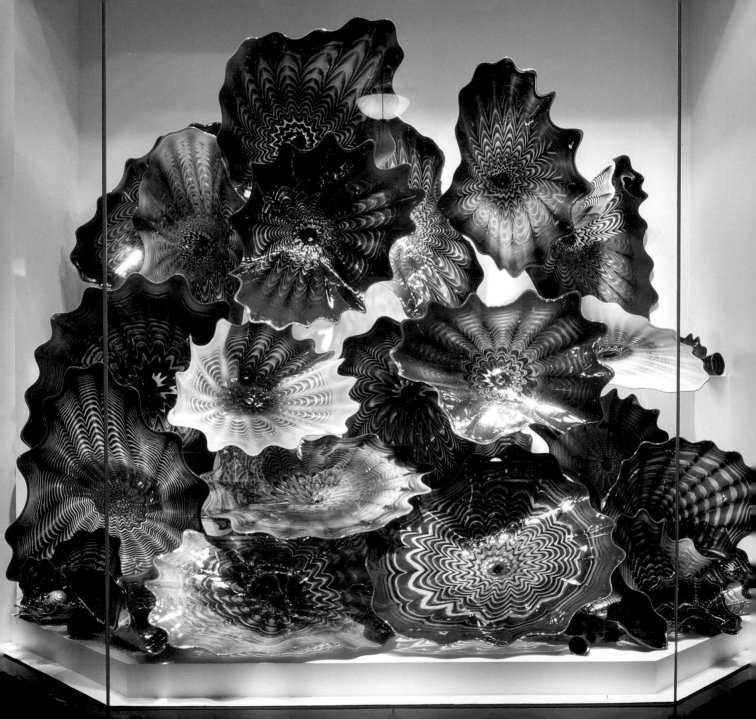

A LIFETIME OF INSPIRATION DALE CHIHULY AND TACOMA

Rock Hushka

God knows, the Northwest has been good to me and has had a major influence on me in ways I can't even imagine.[1]
DALE CHIHULY

Dale Chihuly has earned an indelible place in the history of American art, celebrated for his exuberant style, invention, and technical virtuosity. Despite all that has been written and proclaimed about him, there remains a largely unheralded Chihuly story: A local boy earns international critical acclaim while maintaining unbreakable ties to his hometown. Chihuly embodies traits cherished and celebrated by residents of Tacoma and the Pacific Northwest: a pioneering spirit, incalculable and ceaseless creativity, an infinite capacity to envision something new, and a wholehearted pursuit of success. Tacoma has provided a source of inspiration, a testing ground, a creative laboratory, and a place to commemorate his accomplishments throughout his career.

Chihuly joins the very short list of artists who have won recognition beyond the Pacific Northwest, a list that includes painter Mark Tobey (plates 1 and 2). The esteemed curator and art historian Henry Geldzahler wrote of them:

> Both men are from the Puget Sound area in the State of Washington, the northwestern-most state in America, from the cities of Seattle and Tacoma. Washington's landscape and climate have remarkable similarities to those of China and Japan, its geological cousins (they are all on the Pacific Rim), and Washington's museums and collections have reflected this orientation. Tobey's paintings of the 1950s and Chihuly's glass objects of today share an oriental complexion, a great sensitivity to the underlying rhythms of nature, a sense that the universe can be best reflected in work of modest scale.[2]

Puget Sound Persian Installation
Seattle, Washington, 1991,
10 x 12 x 7 feet

Writing before Chihuly began to envision large-scale installations and massive chandeliers, Geldzahler carefully raised the oft-derided idea that a regional environment plays a critical role in an artist's production. Close examination of Chihuly's art and history provides critical insight into key local and regional influences that are the foundation of his art. Understanding these factors provides insight into the strength and closeness of Chihuly's bonds to Tacoma.

Chihuly was born in Tacoma, Washington, on September 20, 1941. His father was a union organizer and butcher by trade, and his mother a homemaker (plate 3). His early childhood was mostly unremarkable, with no obvious indications that the young lad would become an artist. In a 1991 interview with the local Tacoma newspaper, Chihuly's mother searched for connections to art: "Dale kept all his pencils, colored crayons and such, in a little chest. He was quite organized, and always trying out some new idea of his, too."[3]

Like many children of his generation, Chihuly collected brilliantly colored marbles. He remembers that his first home had a small stained glass panel

1 Mark Tobey, *Northwest Fantasy*, 1953, tempera on paper, 43 x 48½ inches, Tacoma Art Museum, Promised gift of Anne Gould Hauberg

2 *Crystalline Clear Venetian with Clear Coil*, 1991, 15 x 22 x 17 inches, Tacoma Art Museum, Gift by exchange from Rod and Laverne Hagenbuch, Dr. and Mrs. John Shaw, and the artist

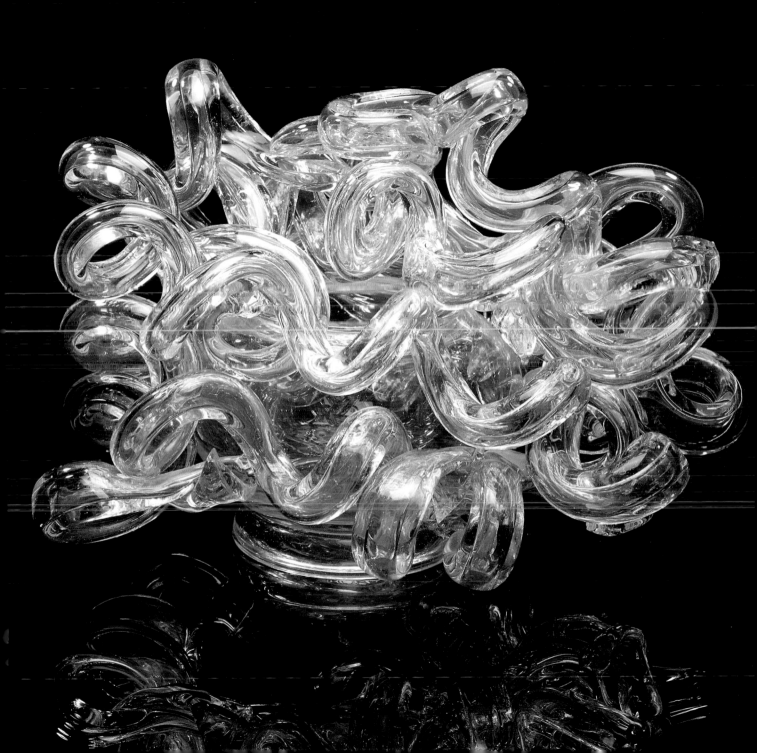

3 With his father George, mother Viola, and older brother George W., circa 1946

4 Barcott's Sea Foods restaurant neon sign, Tacoma, 1953

5 Lincoln Electric neon sign, Tacoma, 1952

6 In his 1957 Alfa Romeo
Giulietta Spider, Tacoma

above the main entrance. On family trips to the beaches on the Pacific Ocean, Chihuly first collected the glass floats that drifted from Japanese waters to Washington State.[4] He also collected small, colorful shards of beach glass along the Puget Sound beaches of Tacoma.[5] Lastly, neon signs proliferated in Tacoma during this period (plates 4 and 5).[6]

Tragedy struck his family in 1957, when Chihuly's older brother and only sibling, George, died in a naval training accident in Pensacola, Florida. Like many younger brothers, Chihuly idolized his older one, whom he remembers as popular, athletic, and success-bound. Chihuly's fondness for sports cars was instilled by George (plate 6). His father's death of a heart attack the following year compounded the family's grief. These two untimely deaths bound the adolescent Chihuly to his mother. He maintained ties to Tacoma largely because of his relationship with her. During the early years of his career, when he was away from the region, Chihuly maintained almost daily contact with his mother through postcards and telephone calls.[7]

His mother was certainly one of the most important figures in Chihuly's life. Viola Chihuly fostered a profound awareness of color and form in her son through her extensive garden (plates 7 and 8), her love of sunsets, and her appreciation of the region's natural beauty. Timothy Anglin Burgard, the Ednah Root Curator in Charge of American Art at the Fine Arts Museums of San Francisco, summarized:

> The artist's fascination with color can be traced to vivid childhood memories of his mother's abundant flower gardens and the spectacular sunsets he and his brother viewed with her. As Viola Chihuly later recalled in a newspaper interview, "I'd be right in the middle of peeling potatoes or something, and I knew just when the sun was about to set because I could see it from our kitchen window. I'd clap my hands, which meant, 'Come on, we're going to run up the hill.' And we'd tear up to the top, one on each side, me holding on to their little hands as they flew up there. All my life I've been crazy for sunsets." The reporter concluded, "She is not alone. Chihuly says that, for him, color is always an outgrowth of nature—sunsets, to be sure, the treasures of the sea, the vibrant flower gardens he was always warned not to step on as youth.[8]

7 With his mother, circa 1943

8 *Buddha Red Ikebana with Orange and Scarlet Stems,* 2001, 55 x 45 x 20 inches, W. W. Seymour Botanical Conservatory, Tacoma, 2008

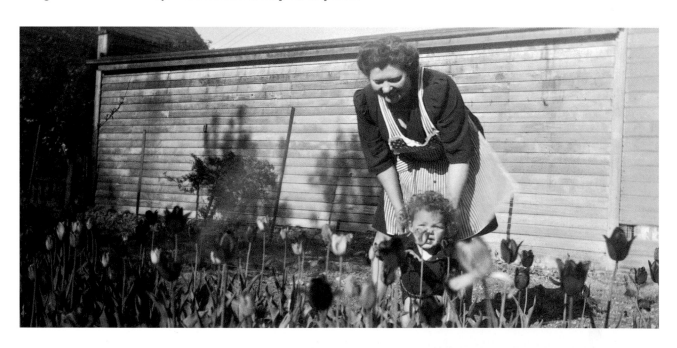

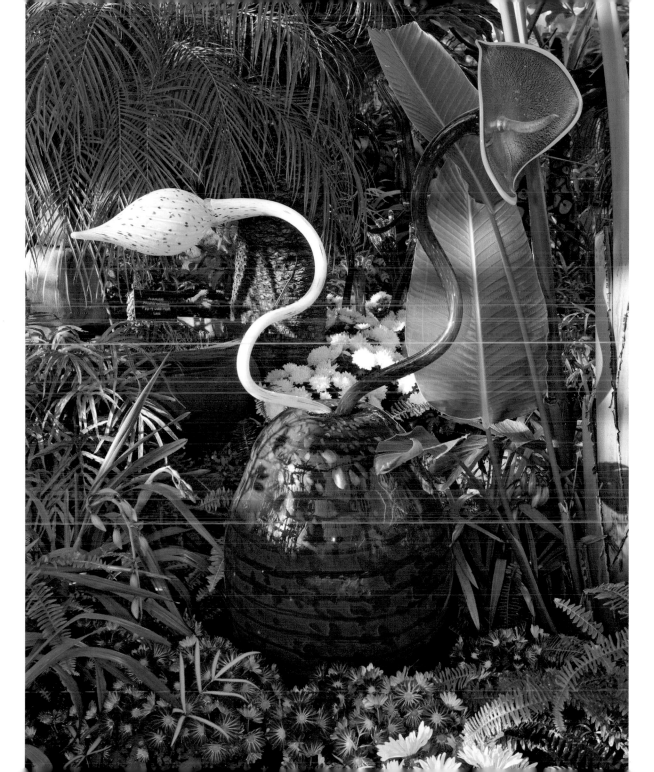

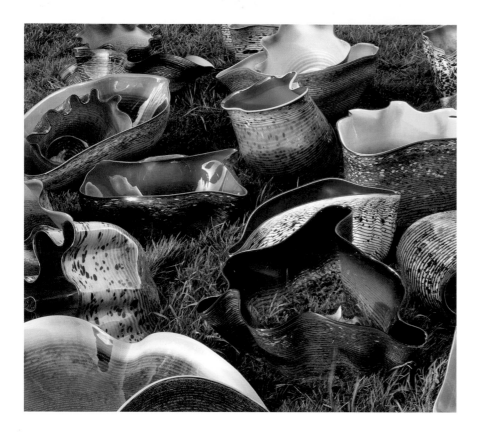

9 *Macchia* group, Pilchuck
 Glass School, Stanwood,
 Washington, 1986

10 *Mille Fiori* (detail), Tacoma
 Art Museum, 2003

His mother's skill as a gardener and her ability to coax complex forms and
colors from nature resonate throughout Chihuly's career.[9] When he devel-
oped the *Macchia* series, which depended on the availability of colored glass
that he procured directly from German factories, Chihuly photographed a
set on the lawn at the Pilchuck Glass School that he cofounded (plate 9). His
thinking about gardens would later inspire the *Ikebana* and *Mille Fiori* series
(plates 8, 10, and 11).

Mrs. Chihuly insisted that Chihuly attend college, so he enrolled at the
College of Puget Sound in Tacoma (today the University of Puget Sound) in
1959 and transferred to the University of Washington in Seattle the following
year. During his studies, Chihuly first investigated fused glass as a component

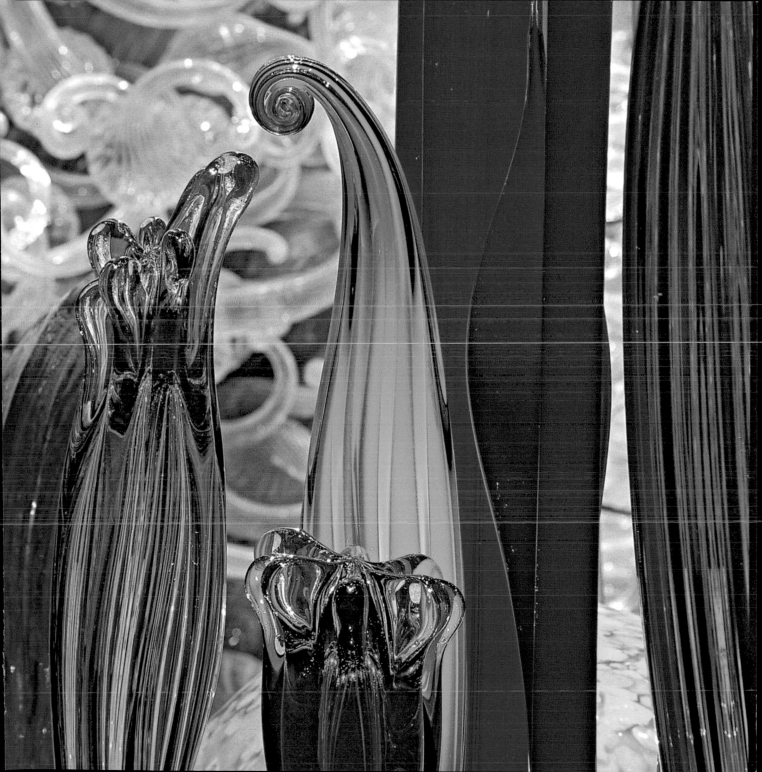

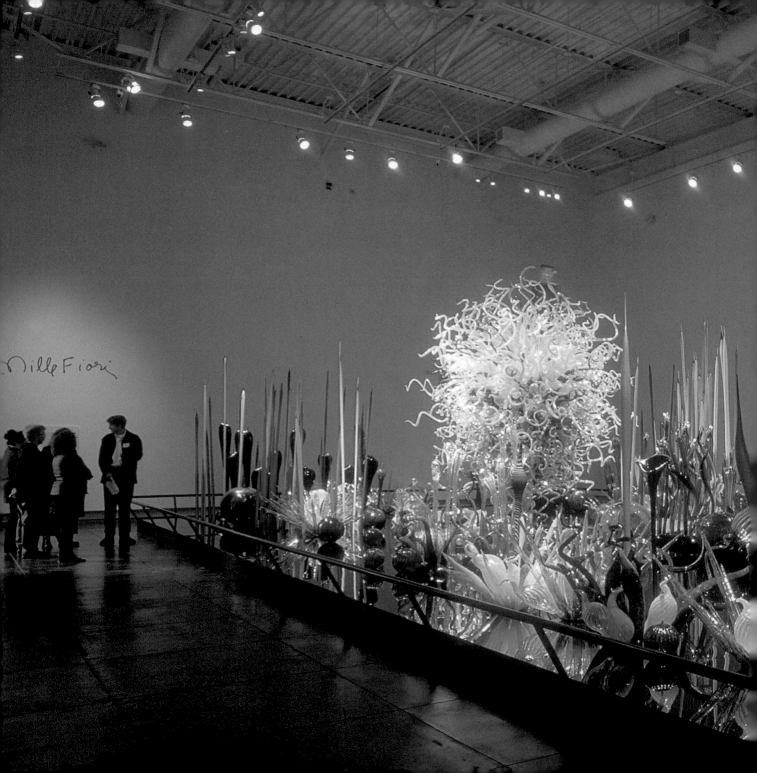

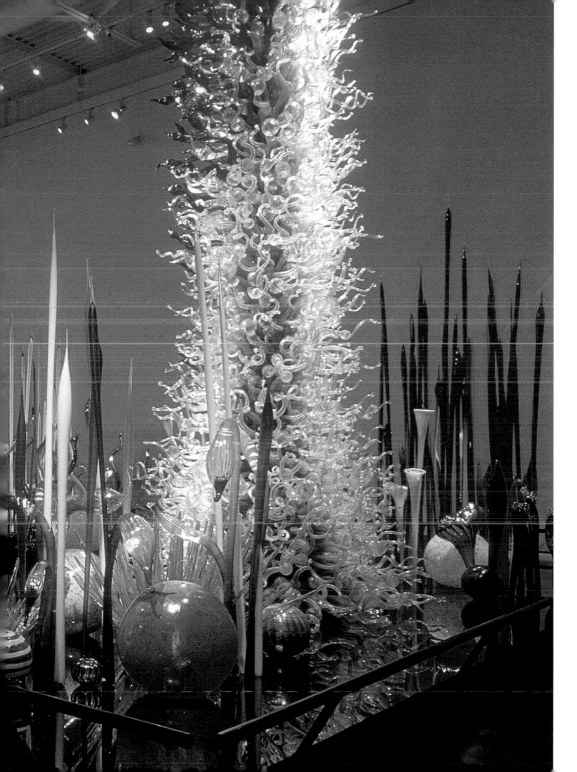

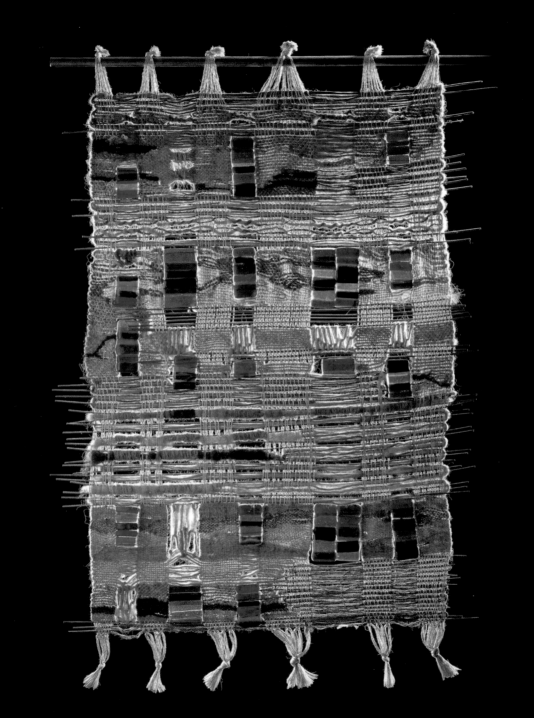

of ambitious handwoven hangings (plate 12). One of these early weavings was designed for his mother's dining room (plate 13). His early command of textiles would become central to his work from the early 1970s through the late 1980s.

For many decades, Mrs. Chihuly's home remained an important place for the artist to refresh himself and move forward. The poster announcing the inaugural year of the Pilchuck Glass School included the instructions: "Recipients are to meet at Dale's mom's house in Tacoma, Washington."[10] The final decision regarding the site of the new glass school was made around Mrs. Chihuly's dining room table.[11]

His mother instilled a sense of generosity in the artist. Longtime neighbor Gardner Mayo said, "The one thing is, he always wanted to help everyone. He got that from Vi."[12] This central character trait is remembered fondly by those who experienced the mother-son team in action. In 1975, for example, while Chihuly was an artist-in-residence at Snowbird in Utah, Mrs. Chihuly arrived with suitcases packed with Northwest salmon. Chihuly asked his

mother to bring this symbol of the Northwest to serve at a party.[13] Chihuly's generosity to Tacoma is demonstrated by the major, permanent installations that the artist has given to the city.[14]

In the era of Chihuly's childhood, Tacoma was a gritty blue-collar port city with paper mills, manufacturing, and the nearby military installations of Army post Fort Lewis and McChord Air Force Base. Set on steeply rising hills on Puget Sound's Commencement Bay, Tacoma had a thriving downtown until the advent of the shopping mall in the early 1960s. In the mid-nineteenth century, Tacoma grew from a small lumber mill on the banks of Puget Sound, its future firmly established in 1873 when the Northern Pacific Railway selected the town as the West Coast terminus for the transcontinental railway. From its earliest years, Tacoma was a frontier town where new beginnings could be made and fortunes created. In 1889, visiting Rudyard Kipling famously wrote that Tacoma "was staggering under a boom of the boomiest."[15]

The city's moniker, "The City of Destiny," proclaimed its faith in itself and its citizens. Its role as railroad terminus and seaport reinforced the belief that important things would happen here. Boosterism was a defining characteristic of the city, and all things seemed possible through hard work and a bit of luck in finding the right opportunities. Despite setbacks such as the financial panic of 1893 and the ascendency of Seattle during the Klondike Gold Rush that began in 1897, the frontier mentality has held sway in the city's mythology and sense of self.

Spurred by this spirit, Chihuly continually demonstrates a fearlessness and sense of wonderment at each stage of his career. It underscores his approach to glass as a limitless, expressive medium. It drives his experimentation with scale, texture, color, forms, and thinness. One of Chihuly's favorite motivators has always been, "If I can just get it started, I can pull this off!"[16]

In the Northwest, Chihuly was free to sidestep the restrictions, conventions, and formalism of the Eastern academies and avoid the rigid traditions and strict hierarchies characteristic of European glass production. The Northwest encouraged new ways of thinking and of collaborating. This undoubtedly inspired Chihuly to site the Pilchuck Glass School in the Northwest (plate 14).

14 *Forest Green and Silver Pilchuck Stump,* 1992, 20 x 10 x 9 inches

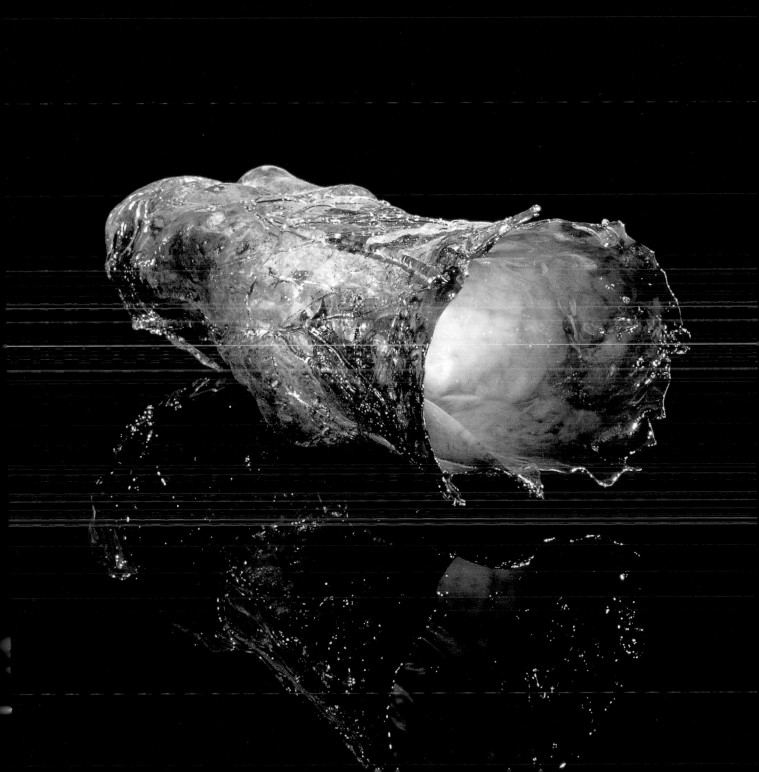

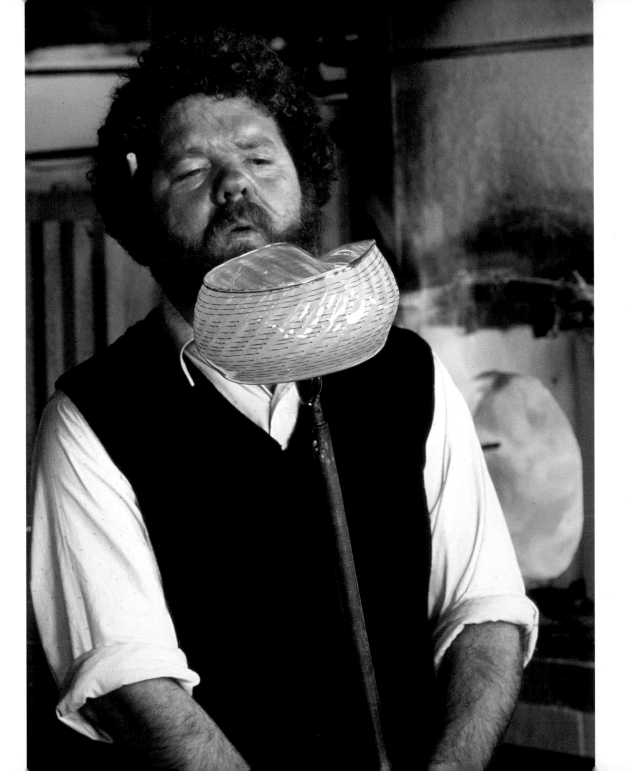

Chihuly has stated, "Right from the get go, I never even considered situating it outside the borders of Washington State. The temperate Northwest climate was perfect, and we liked the idea of art students hitting the road and heading West to work in a rugged new landscape."[17] The region's spirit fostered an unconventional synthesis of source materials and experience. In a 2008 interview, Chihuly elaborated his position: "This stuff they learned from Venice—we were trying to break it. It became so decadent. . . . But at Pilchuck they tried to start afresh. Brand new. It was very primitive. . . . Rough. Very American, very Northwestern. I thought it was very, very original."[18]

Before returning to the Northwest, Chihuly studied with Professor Harvey Littleton, the founder of one of the nation's first glass programs, at the University of Wisconsin–Madison and earned a Master of Science in Sculpture in 1967. Later that year, he enrolled in the ceramics program at the Rhode Island School of Design and received a Louis Comfort Tiffany Foundation Grant. In 1968, Chihuly completed his Master of Fine Arts degree and received a Fulbright Fellowship, which allowed him to work in the fabled Venini Fabrica on the island of Murano near Venice. By 1980, Chihuly had established a strong critical reputation through exhibitions in Europe, South America, and throughout the United States, including the Contemporary Craft Museum in New York City (today the Museum of Arts and Design) and the Renwick Gallery, Smithsonian Institution, Washington, D.C.

Through his establishment of the Pilchuck Glass School, the energy of the nationwide glass art scene shifted securely to Seattle. Chihuly built a base of operations and propelled his career forward. Because of the national reputation that he had solidified on the East Coast, he returned as a mature figure in the art world, widely lauded by collectors, critics, and curators.[19] Chihuly became the center of artistic creativity in Seattle and Tacoma upon his return, and fulfilled the role of charismatic maestro with the same passion with which he had founded the glass school and established the glass program at the Rhode Island School of Design (plate 15). Through the glass school, Chihuly was able to nurture and encourage a pool of artists who were able to help realize his ambitious projects and push glass into ever increasingly dazzling

technical virtuosity and greater scale. His experimentation and success were widely shared through his ethos and his hotshop system. Even a partial list of artists of Chihuly's collaborators reads like a Who's Who of the art glass movement: Martin Blank, Benjamin Moore, Joey DeCamp, Flora C. Mace and Joey Kirkpatrick, James Mongrain, William Morris, Richard Royal, Pino Signoretto, and Lino Tagliapietra. Chihuly also invited other important glass artists to participate at the Pilchuck Glass School, including Ginny Ruffner, Curtiss Brock, Ann Gardner, and Paul Marioni.[20]

When Dale returned to the Pacific Northwest in 1983, his decision was based primarily on his ability to earn a living from sales of his art and his desire to live near the glass school. In retrospect, the pull of open-ended opportunities and his ties to his mother in Tacoma make the move back to the Northwest appear preordained. His return was timed perfectly—his rise to international acclaim roughly parallels other recent Northwest success stories, including those of Microsoft, Starbucks, and the nascent "grunge" music scene.

16 Dale Chihuly wrapped in a wool Native American trade blanket, Old Harbor, Block Island, Rhode Island, 1973

Chihuly's remarkable entrepreneurial impulses flourished in the Northwest and were supported by a host of practical realities.[21] In Seattle, he found cheap electricity created from hydroelectric dams on the Columbia River system, which helped him keep his business expenses lower even while the glass furnaces were fueled by natural gas or propane. Real estate was inexpensive. He was able to build his studio and expand relatively quickly and easily, compared to what he could have done in New York City or Providence, Rhode Island. Also significant was Seattle and Tacoma's newly supportive and expanding base of collectors, notably the cofounders of the Pilchuck Glass School, John Hauberg and his first wife, Anne Gould Hauberg.

One of the defining features of the Puget Sound area is the abundance of water. Tacoma and Seattle are ports on the Sound, both with stunning views of the water. Puget Sound is visible from the Pilchuck Glass School, and Chihuly sited his lodging there with a view of the water. Curator Timothy Anglin Burgard noted the lifelong connection between Chihuly and Puget Sound: "Chihuly has spent most of his life on or near Puget Sound. . . . Chihuly's deep ties to water in all its forms (plate 16) span from childhood walks along the beaches of Puget Sound to his mature career, in which he situated the two versions of his Boathouse studio on the water—the first (1980–1983) on Pawtuxet Cove, Rhode Island, and the second (1990–present) on Lake Union in Seattle."[22]

The region's mild climate is defined by a nearly constant chance of rain or mist for most of the year, excluding high summer. Chihuly once remarked that rain provides a ceaseless source of inspiration: "One of the great attractions of being in the Northwest is the rain. I find the rain very creative. Water is the one thing that I can assure you is a major influence on my work and my life and everything I do. . . . If I don't feel good or I don't feel creative, if I can get near the water something will start to happen."[23]

The ever-present water, whether as rain or vapor, has a profound effect on the quality of light in the Northwest. The water scrubs the light, bathing the region in a clean, soft luminosity. Sometimes described as an "oyster light" owing to the silvering effect of overcast skies, it has an almost tangible

quality. During overcast days, no shadows fall, and light magically engulfs objects and bathes them in a soft glow. The ubiquitous rain of the Pacific Northwest gives everything a glossy coating that reflects light. In the night-time, colored light from cars and signs bounces and shimmers. The effect of rain-coated objects might be best described as a thin layer of glass, providing a shiny sheen to nearly every tangible thing. Through the mind of someone passionate about and committed to glass, the sheen and reflections of rain-soaked surfaces would almost certainly provide an endless source of inspira-tion and stimulation (plate 17).

Water intensifies colors. Things appear deeper, more saturated, and have a pristine quality about them when soaked by rain. In the Northwest, this intensity is manifested by deeply hued evergreen forests and vibrant grass and gardens throughout most of the year. When the sun does break through the cloud ceiling, a low-grade celebration bursts through the population. The relative rarity of warm, sunny days creates a culture that attempts to maximize the precious commodity. In the direct sun, colors appear new and different, appealing once again to the artist seeking inspiration from the natural environment.[24]

In terms of process, the physical properties of water also relate closely to glass. In its molten form, glass is an extremely viscous liquid and moves in ways similar to water. These qualities allow Chihuly to coax molten glass into his characteristic swells and undulations. One of his first projects at the Pilchuck Glass School was an installation of clear bubbles that he floated into a pond (plate 18). Through the process of mastering molten glass, Chihuly has further connected to the primal attraction to water and desire to control it (plate 19).

Chihuly has also explored the frozen state of water. In his early installa-tion *20,000 Pounds of Ice and Neon* (1971), a collaboration with James Carpenter at the Rhode Island School of Design Museum of Art, Chihuly brilliantly used ice to move colored neon-produced light. The ice transmitted light like glass and produced a glassy sheen as it melted. Chihuly would return to the neon and ice project on multiple occasions, including the spectacular *100,000 Pounds*

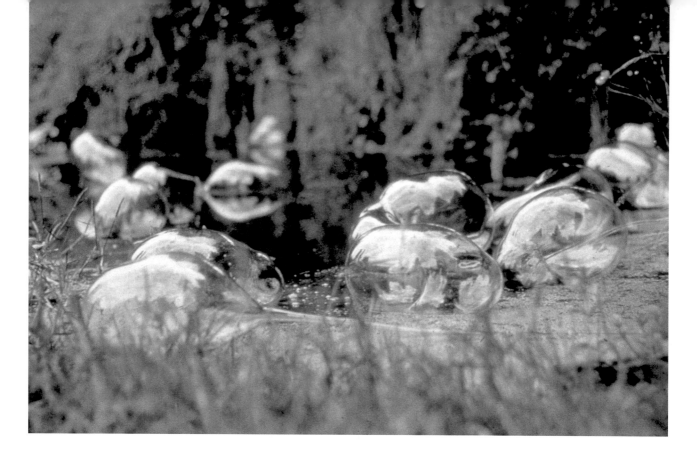

of Ice and Neon at the Tacoma Dome in Tacoma in 1993 (plate 20). He used glass as a substitute for ice in his magnificent sculpture *Icicle Creek Chandelier* (plate 21), which defies time and the seasons. Awareness of the relative fragility of glass and the ever-changing conditions of wind and weather make *Icicle Creek Chandelier* one of Chihuly's most arresting and compelling works. It embodies his remarkable ability to produce dynamic interplay between form and scale, and between artificiality and the representation of natural forces.

Art historian Donald Kuspit emphasizes water as a key psychological force in Chihuly's development, and posits an inseparable relationship between the feminine experience (i.e., motherhood and nurturing) and the universality of water:

18 *Pilchuck Pond Installation,*
 Pilchuck Glass School,
 Stanwood, Washington, 1971

19 *Sky Blue Basket Set with Cobalt Lip*
 Wraps, 1992, 17 x 15 x 16 inches

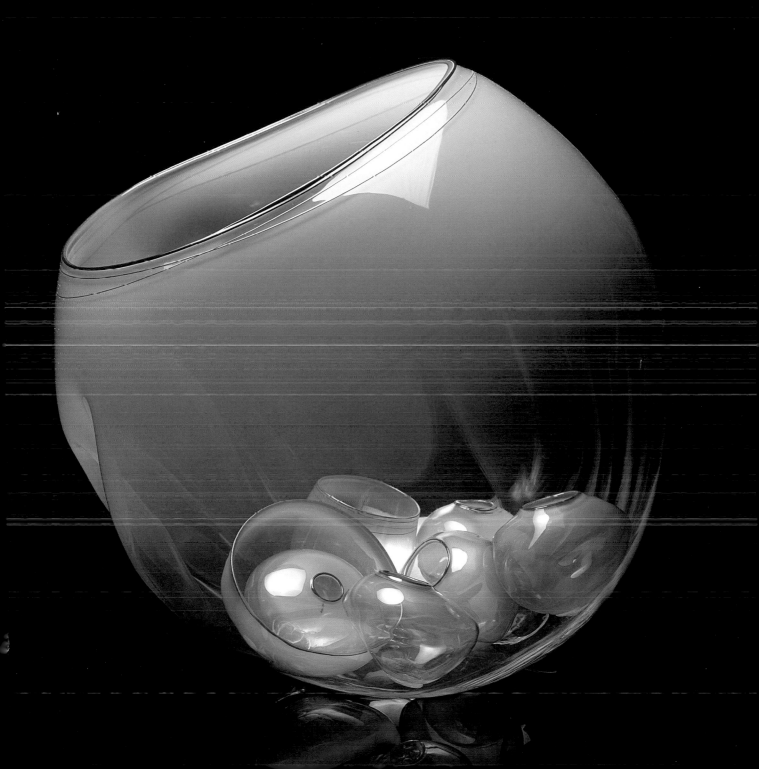

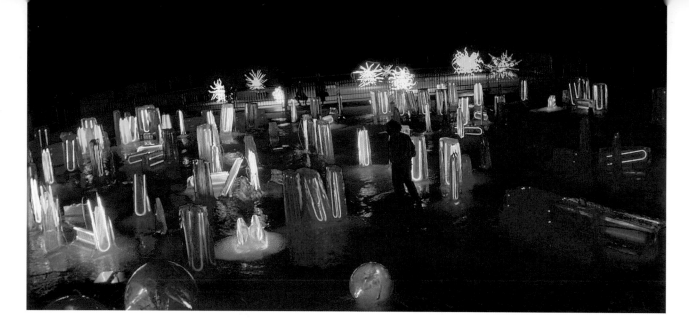

Chihuly's preoccupation with femininity is inseparable from his preoccupation with the forest, a concern clearly related to the Northwest environment in which he grew up. The experience of being surrounded by trees in a forest, in effect lost in a forest, is "feminine"—that is, oceanic. . . . As early as 1971, in the *Pilchuck Pond* installation, Chihuly was making feminine bulbs of glass, as curved as a woman's body, harmoniously floating on water—another feminine element. . . . The sensation of floating freely is inseparable from the oceanic experience. It also occurs when one is deep in the forest, cut off from civilization.[25]

Kuspit's assertion supports the observation of a profound sense of place in Chihuly's sculptures and installations. Chihuly's mastery of these powerful and universal forces infuses his art with an emotional impact that conveys the depth of his bonds to his family and his deep appreciation for the experiences nurtured by Puget Sound. He memorably captured the interconnectedness of these primal forces in his exquisite *Ma Chihuly's Floats* (plate 22).

Parallel to familial and environmental influences in Chihuly's art, Tacoma and the Northwest have provided inspiration and career-defining opportunities.

20 *100,000 Pounds of Ice and Neon*, Tacoma Dome, 1993

21 *Icicle Creek Chandelier*, Sleeping Lady Conference Retreat, Leavenworth, Washington, 1996, 12 x 9 x 6 feet

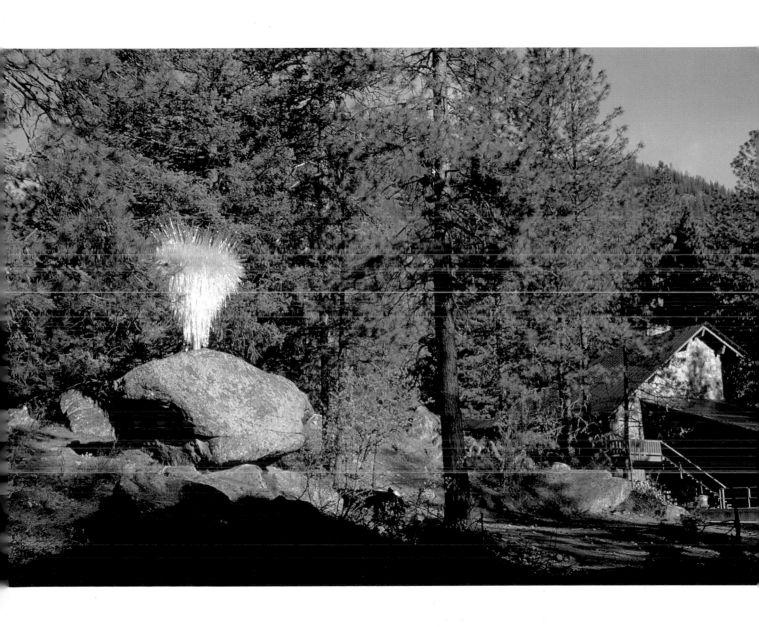

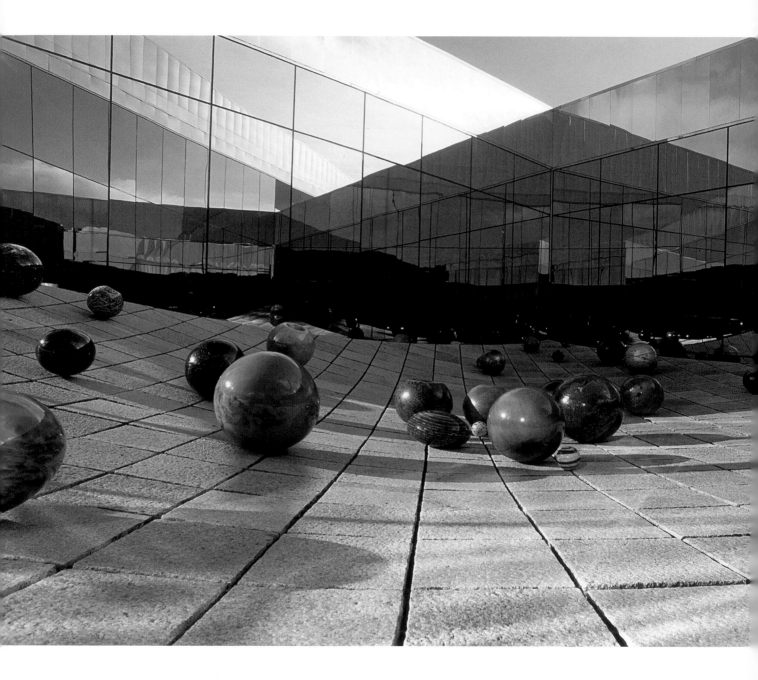

22 *Ma Chihuly's Floats*, 2006, Tacoma Art Museum, Gift of Dale, Leslie, and Jackson Chihuly in honor of Viola Chihuly

23 Dale Chihuly's truck with bumper sticker "Visualize Tacoma"

The most obvious is Chihuly's role in the realization of the Pilchuck Glass School.[26] Less understood is Chihuly's use of Tacoma as a font of conceptual ideas and a laboratory in which to expand his art in scope and complexity. Tacoma has remained vital to advances in his art throughout his entire career. Chihuly's fondness and aspirations for the city, as well as his idiosyncratic style, were famously displayed on his pink truck with a bumper sticker that instructed "Visualize Tacoma" (plate 23).

Chihuly's first artistic connection to Tacoma was through the gift of the weaving to his mother. The successful realization of these early weavings fostered his interest in glass.[27] Chihuly's commitment continued with a letter to the city's newspaper in which he urged preservation of the historic City Hall.[28] In 1971, Chihuly's exhibition history started at Tacoma Art Museum's *1st National Invitational Hand Blown Glass Exhibition* with *All the Way Out to East Cupcake*, a collaborative work with James Carpenter (plate 24).

Very significant to Chihuly's development as an artist has been his life-long interest in Native American culture and imagery. As a child, he was a frequent visitor to the Washington State Historical Society. In the late 1960s, he began to collect wool American Indian trade blankets, particularly those woven in the Pendleton Mills. Chihuly remembers, "I'd see these blankets and go, 'Wow!' I mean, how can you not collect them? There was no market for them. I'd get 'em for $5 in thrift stores."[29] Chihuly signaled the extent of his interest in Native American imagery by including a reproduction of one of Edward S. Curtis's photogravures from the *North American Indian* in the announcement of the inaugural class of the Pilchuck Glass School.[30] Later, Chihuly displayed his collection in The Northwest Room in The Boathouse, featuring wool trade blankets, historic Northwest Coast Native American baskets and wood carvings, Curtis's *North American Indian* photogravures, an Algonquin birchbark canoe, and a 1915 Indian Twin motorcycle, along with a selection of his own glass *Baskets* and *Cylinders* (plates 25 and 26).

Chihuly's interest in Native American culture was supported by a resurgence of Native American culture and politics nationwide in the late 1960s and early 1970s, such as the emergence of the American Indian Movement.[31] Locally, Chihuly had access to the collections at the University of Washington's Burke Museum of Natural History and Culture in Seattle. He knew of the scholarship of Professor Bill Holm, notably his groundbreaking *Northwest Coast Indian Art: An Analysis of Form* first published in 1965, and he knew John Hauberg's exquisite collection of Native American Northwest Coast art (now in the collection of the Seattle Art Museum). The landmark "Boldt Decision," a contentious and long-simmering local issue, made national headlines in 1974 when Justice George Boldt of the District Court for the Western District of Washington in Tacoma reaffirmed the traditional right of Native Americans to harvest salmon.[32]

As with the wool trade blankets, Chihuly had a keen interest in the textile traditions of Southwest Native American cultures. In 1974, he helped build a glass shop for the Institute of American Indian Arts in Sante Fe, which allowed him extensive access to historic Southwest Native American textiles. Chihuly

24 *All the Way Out to East Cupcake,* Dale Chihuly in collaboration with James Carpenter, exhibited in the *1st National Invitational Hand Blown Glass Exhibition,* Tacoma Art Museum, 1971

25 The Northwest Room, The Boathouse, Seattle, 1999

26 *Cylinder* and *Soft Cylinder* with Edward S. Curtis photogravures, Native American baskets, and carved bench by Duane Pasco, The Boathouse, Seattle

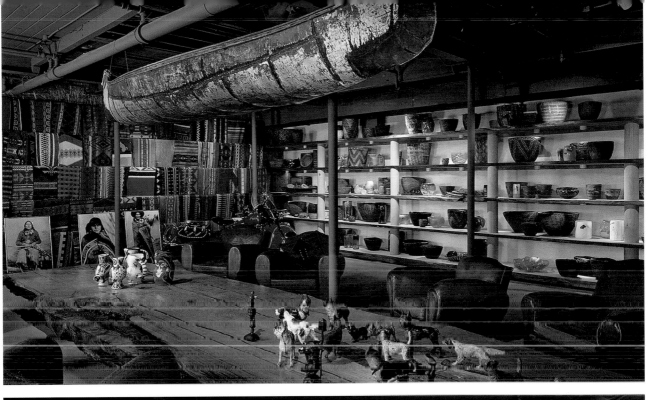

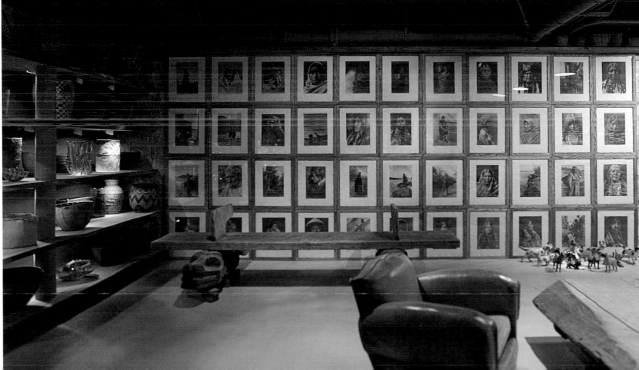

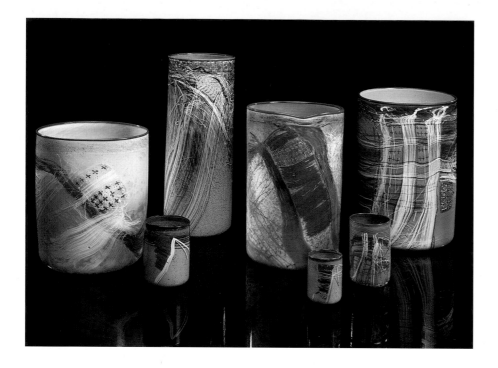

also cites the blankets seen in Andy Warhol's *Raid the Icebox 1: With Andy Warhol* at the Rhode Island School of Design Museum of Art in 1970 and at an exhibition at the Museum of Fine Arts, Boston, in 1975 as significant inspirations.[33] He utilized his knowledge of these textiles in his *Navajo Blanket Cylinders* (plate 27).

In 1977, after a visit to the Washington State Historical Society, Chihuly began the *Pilchuck Basket* series (plate 28). As he said, "In 1971, the summer we started Pilchuck, Jamie Carpenter started collecting Northwest Coast Indian baskets. A few years later, when Jamie, Italo [Scanga] and I were visiting the Washington State Historical Museum, I looked at baskets and thought I would try to make them in glass. I wanted mine to be misshapen and wrinkled like some of the older baskets I had seen in storage there"[34] (see plate 52).

In the *Baskets*, *Cylinders*, and *Soft Cylinders* series, Chihuly synthesized his love of Native American imagery, the pliable plane of blankets and baskets,

27 *Cylinder* group, 1984–85, tallest 17½ inches, Tacoma Art Museum, Gift of the artist in honor of his parents, Viola and George, and his brother, George W. Chihuly

28 *First Baskets*, approximately 3 x 24 feet, Seattle Art Museum, 1977

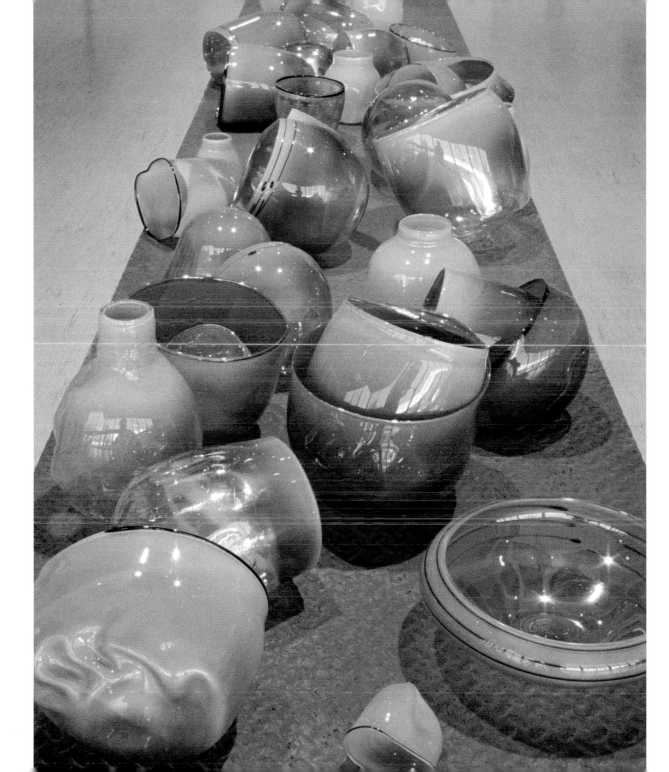

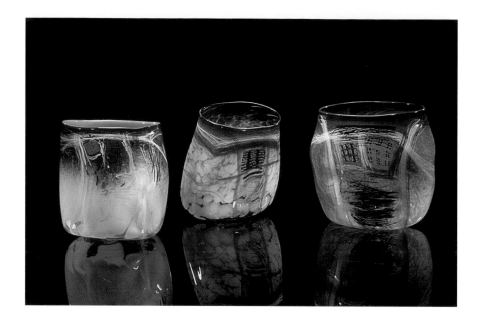

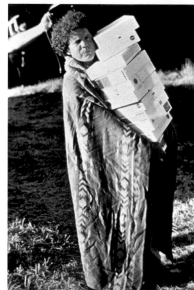

his abilities in handwoven textiles, and his mastery of glass blowing and
the drawing technique he had developed and refined collaboratively with
Kate Elliott, Flora C. Mace, and Joey Kirkpatrick. Chihuly reflected, "I think
it is possible to say that in both series, the *Navajo Blanket Cylinders* and the
Baskets, the pieces were wearing their drawings just as the Indians were
wearing their blankets"[35] (plates 29 and 30).

Experimentation with the undulating forms of the *Blanket* and *Basket*
series expanded to *Seaforms* in 1980. Chihuly showed his *Seaform* series early
in Tacoma, together with some of his earlier *Baskets*, in the inaugural exhibi-
tion of glass artists at the newly restored Bodega Court in July 1981. Reviewing
for *Northwest Arts*, curator and art historian LaMar Harrington wrote glow-
ingly, "For sheer beauty of concept and execution, the outstanding works
are those by the master, Dale Chihuly. The delicacy of form and color and
surface design of his group of distorted vessel forms, nestled together or
shown separately, is breathtaking."[36] Later in October, Chihuly opened
his first one-person exhibition at Tacoma Art Museum, *Dale Chihuly: Glass*

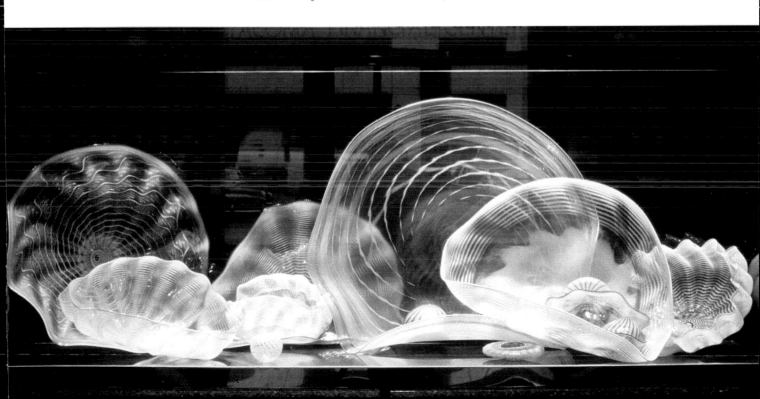

29 *Soft Cylinders*, 1984–86, Tacoma Art Museum, Gift of the artist in honor of his parents, Viola and George, and his brother, George W. Chihuly

30 Dale Chihuly wrapped in a wool Native American trade blanket, Pilchuck Glass School, Stanwood, Washington

31 *Seaform Installation*, Tacoma Financial Center, 1984, 3 x 6½ x 2½ feet

Blowing. He described the new work as an evolution from his *Basket* series.[37]

Chihuly radically increased the scale of his work in 1984 with the installation of a white *Seaform* group for the lobby of the new Tacoma Financial Center (plate 31). He told an interviewer, "It's the largest single piece I've ever put together and the only time I've ever shown in this manner."[38] Chihuly and architects Gordon Walker and Dennis Alkire collaborated on the conception of the lobby casework, scale, and color for the 3 by 6½ foot-long installation. A few years later, Chihuly created a similar installation of an early work from his *Persian* series for the Frank Russell Company (plate 32). These early commissions laid the foundation for future architectural installations.

In 1987, Chihuly lent thirty-three works to the Tacoma Art Museum, which were installed in a newly constructed gallery on the museum's third floor (plate 33). These works represented all of his series to date and were donated to the museum in 1990 in memory of his father and brother. This retrospective installation inspired future exhibitions that would be

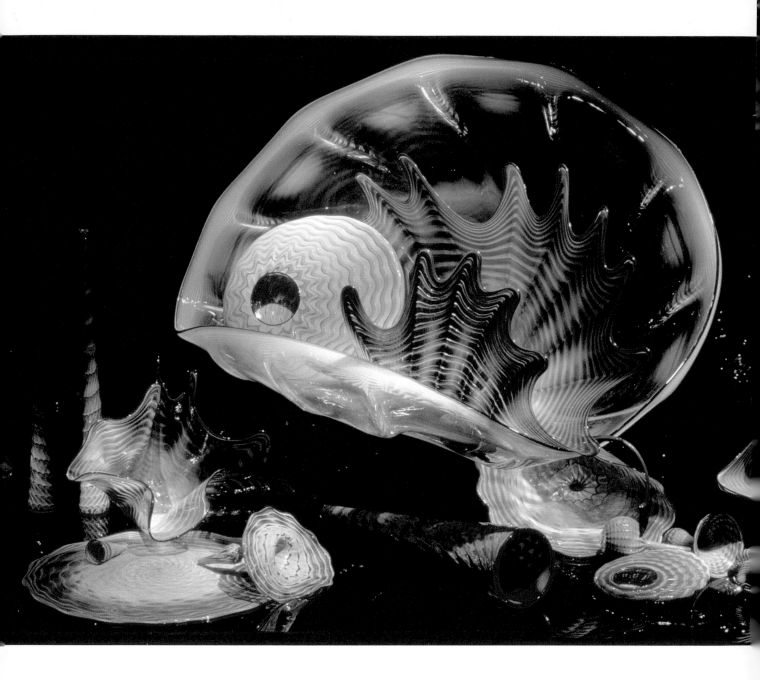

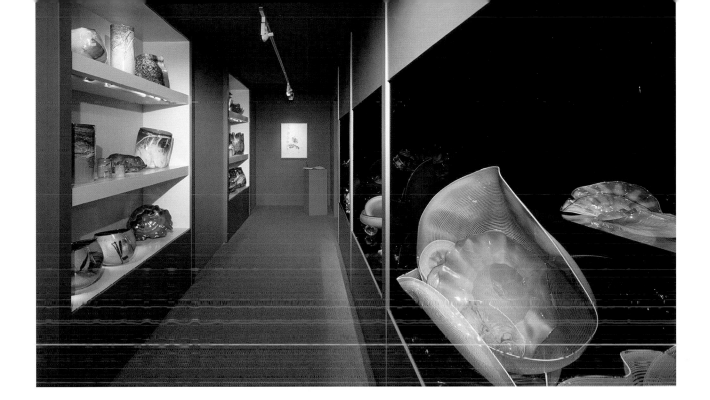

comprised of increasingly larger-scaled installations in galleries featuring a single series. Chihuly continued his relationship with the Tacoma Art Museum with *Chihuly: Works on Paper* in 1991–92 and *Mille Fiore* in 2003 (see plates 10 and 11). *Mille Fiore*, which christened the Tacoma Art Museum's new building, marked the beginning of a major new series from which Chihuly would create a new iteration for his participation in the 53rd *Venice Biennale* in 2009. He would make significant additional contributions to the museum's collection, including four works from the *Ikebana* series in 2004 and the installation *Ma Chihuly's Floats* in 2006, given in honor of his mother (see plate 22). Displayed each spring and summer since, *Ma Chihuly's Floats* maximizes the endless wavelike reflections of the museum's central courtyard, designed by architect Antoine Predock and landscape architect Richard Rhodes. The courtyard was designed to evoke the waters of Puget Sound.

 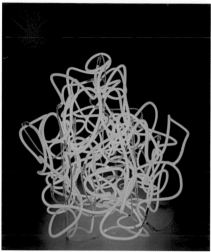

Chihuly's most critical use of Tacoma as a testing ground occurred in
1993–94, when he orchestrated a three-day installation, *100,000 Pounds of
Ice and Neon*, in 1993 at the Tacoma Dome (plate 34) and, in collaboration with
the Tacoma Art Museum, presented five installations of large-scale works at the
U.S. Federal Courthouse at Union Station in 1994. Both were the largest-scale
efforts to date for the artist and his studio, and both were accompanied by
massive public relations efforts. These projects helped prepare Chihuly and his
studio for the gigantic *Chihuly Over Venice* installation in 1996. Beginning in
1994 with his Seattle-based hotshop team, Chihuly worked with glassblowing
factories in Nuutajärvi, Finland; Waterford, Ireland; and Monterrey, Mexico, to
create fourteen massive *Chandeliers* that would be installed around Venice. This
worldwide project was recorded for high-definition broadcast, the first major
program of its kind, and was aired by public broadcasting stations in 1998.

In 1994, he participated in the founding of Hilltop Artists, a glassblowing
program for at-risk youth in Tacoma, and continues to support the program.
He installed *The Chihuly Window* at the University of Puget Sound, commemo-
rating his first collegiate experience (plate 35). Nearly a decade earlier, in 1986,
the university had granted Chihuly his first honorary doctorate. In 1999, the

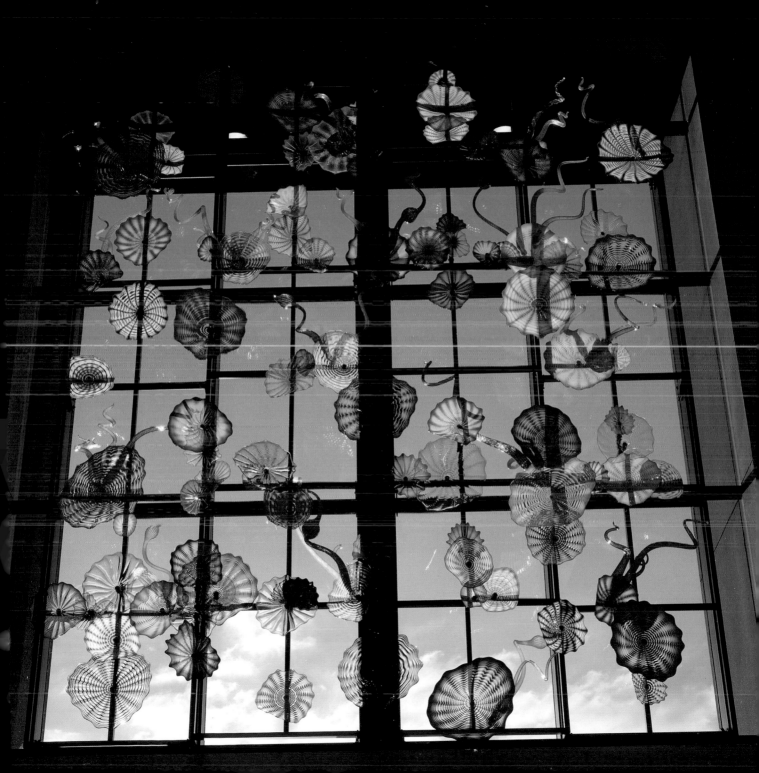

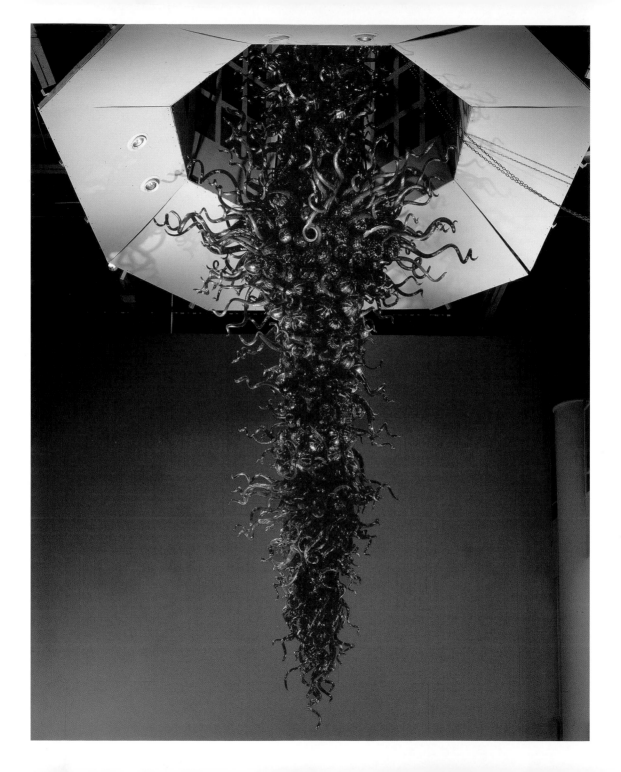

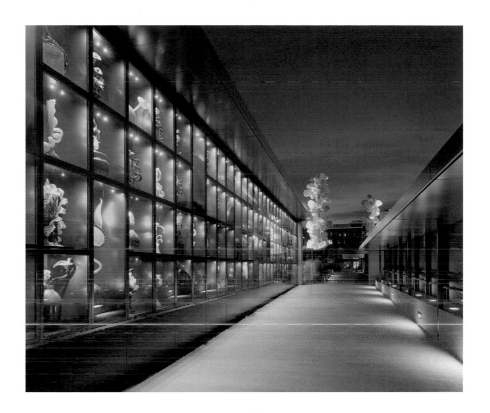

36 *Chinook Red Chandelier,* University
 of Washington Library, Tacoma,
 1999, 21 x 8 feet

37 *Chihuly Bridge of Glass, Venetian
 Wall,* Tacoma, 2002

University of Washington Tacoma commissioned the artist to create the
Chinook Red Chandelier for its new library building (plate 36). In 2002, Chihuly
completed the public art project *Chihuly Bridge of Glass* with the *Seaform
Pavilion,* the *Venetian Wall,* and two *Crystal Towers* (plate 37). He participated in
the *Chihuly in Tacoma* hotshop sessions at the Museum of Glass in 2006, which
reunited the artist with key crew members from each stage of his career.

Most recently, Chihuly contributed to the centenary celebrations for
the W. W. Seymour Botanical Conservatory. The artist fondly remembers how
his mother used to take him there when he was a child. Chihuly added, "I've
always loved this building. This is a beautiful little spot"[39] (plates 38 and 39).
The intimate setting of the Conservatory provided the much-celebrated
Chihuly garden experience for his hometown.

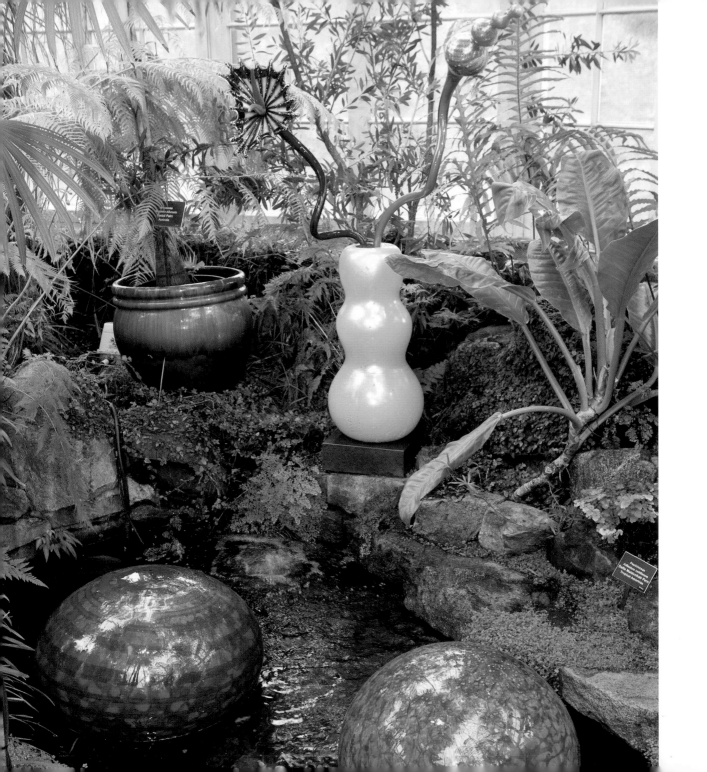

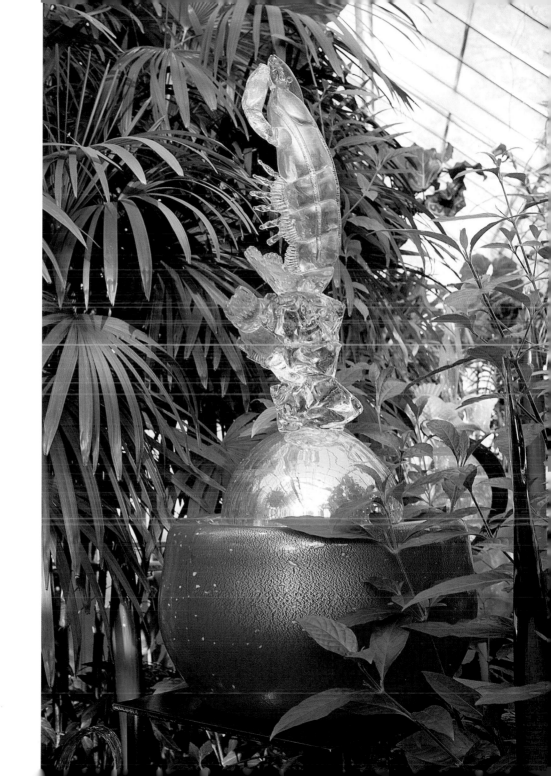

38 *Ikebana* with *Niijima Floats* and *Fiori*, W.W. Seymour Botanical Conservatory, Tacoma, 2008

39 *Venetian* with putto carrying lobster on gilded orange base, W.W. Seymour Botanical Conservatory, Tacoma, 2008

Architectural historian and preservationist Michael Sullivan distilled the importance of Chihuly to Tacoma:

> Without him there might be no new Tacoma Art Museum, now under construction on Pacific Avenue, and no downtown theater district. In Tacoma in the '90s, the most recognized Tacoman was an artist, and for a working-class town, that's quite an interesting phenomenon. It gave conservative thinkers permission to accept the cultural development that went on in the '90s. Dale showed that the arts were a path to legitimate success. Tacoma's economy benefited from Chihuly's skyrocketing fame. From 1990 to 2000, he bought three buildings downtown and moved his worldwide shipping operation here. With about 45 employees, he is the largest private cultural employer in Tacoma. He also helped start, and continues to support, community programs such as Hilltop Artists-in-Residence and Seniors Making Art. And he donated much of the art that's on public display here.[40]

Throughout his career, Chihuly has nurtured a strong relationship with Tacoma. He has remained steadfastly loyal to his hometown. The city has inspired him and afforded him repeated opportunities to challenge himself to greater achievements. Chihuly synthesized the city's influences and transformed them into sculptures and installations. He has returned the city's gifts to him with priceless gifts of his own art.

NOTES

1. Patterson Sims, "A Founder's Perspective: Conversation with Dale Chihuly," in Tina Oldknow, *Pilchuck: A Glass School* (Stanwood, Washington: Pilchuck Glass School in association with the University of Washington Press, Seattle, 1996), 25.

2. Henry Geldzahler, "Chihuly at the Louvre: Objects de Verre," in *Dale Chihuly: objets de verre* (Paris: Musée des Arts Décoratifs, Palais du Louvre, 1986), 10.

3. Joan Brown, "Molten Magic," *The News Tribune*, Tacoma, Sunday, September 8, 1991, F11.

4. Interview with Jack Lenor Larsen, New York, August 5, 2010.

5. Patterson Sims, *Dale Chihuly: Installations 1964–1992* (Seattle, Washington: Seattle Art Museum, 1992), 22.

6. Interview with Billy O'Neill, Vice President of Operations, Chihuly Studio, in Seattle, July 14, 2010.

7. Interview with Flora C. Mace and Joey Kirkpatrick, Chimacum, Washington, July 29, 2010.

8. Timothy Anglin Burgard, "Dale Chihuly: Breathing Life into Glass," in *The Art of Dale Chihuly* (San Francisco: Chronicle Books and Fine Arts Museums of San Francisco, 2008), 28.

9. Brown, F12.

10. Dale Chihuly, "Introduction," in *Clearly Art: Pilchuck's Glass Legacy* by Lloyd Herman (Bellingham, Washington: Whatcom Museum of History and Art, 1992), 10.

11. Ibid., 11 and 52–53. Although it was not documented, one may infer from Chihuly's timeline that the initial visit to the Pilchuck site with John Hauberg and John Landon was followed by intense conversation on the drive back to Tacoma from Pilchuck and additional conversation at Mrs. Chihuly's home. Chihuly almost certainly wrote his acceptance letter for the use of the tree farm property for the glass school to Hauberg in Tacoma.

12. Jen Graves, "Prince of Glass," *The News Tribune*, Tacoma, Sunday, June 30, 2002, F5

13. Interview with Flora C. Mace and Joey Kirkpatrick, Chimacum, Washington, July 29, 2010.

14. The artist's website lists no fewer than eight permanent installations. (http://www.chihuly.com/Seasites.html. Accessed August 31, 2010.)

15. Rudyard Kipling, *From Sea to Sea, and Other Sketches* (Garden City, New York: Doubleday, 1927), 2:90–93. See also Murray C. Morgan, *Puget's Sound: A Narrative of Early Tacoma and the Southern Sound* (Seattle, Washington: University of Washington Press, 1979).

16. Interview with Flora C. Mace and Joey Kirkpatrick, Chimacum, Washington, July 29, 2010.

17. Dale Chihuly, "Introduction," in *Clearly Art: Pilchuck's Glass Legacy* by Lloyd Herman (Bellingham, Washington: Whatcom Museum of History and Art, 1992), 10.

18. Burgard, 22.

19. Conversation with James Carpenter, New York, August 5, 2010.

20. Jon Krakauer, "Dale Chihuly Has Turned Art Glass into a Red-Hot Item," *Smithsonian* 22, no. 11 (February 1992), 100. See also Chihuly's "Chronology" (http://www.chihuly.com/chrono/chronA.html. Accessed September 14, 2010.)

21. Interview with Patterson Sims, New York, August 5, 2010.

22. Burgard, 28.

23. Ibid., 30–31.

24. Interview with James Carpenter, New York, August 5, 2010.

25. Donald Kuspit, "Delirious Glass: Dale Chihuly's Sculpture," in *Chihuly* (Seattle, Washington: Portland Press distributed by Harry N. Abrams, New York, 1997), 35.

26. For the official history of the Pilchuck Glass School, see Tina Oldknow, *Pilchuck: A Glass School* (Stanwood, Washington: Pilchuck Glass School in association with the University of Washington Press, Seattle, 1996).

27. Sims, *Dale Chihuly: Installations 1964–1992*, 22. See also Kuspit, 36.

28. Dale Chihuly, "Native Tacoman Makes Plea," *The News Tribune*, Tacoma, Saturday, June 11, 1966, 6.

29. Bart Ripp, "Chihuly Makes a Blanket Endorsement," *The News Tribune*, Tacoma, Tuesday, December 19, 2000, SL4.

30. Burgard, 23.

31. Ibid.

32. For a brief description of the Boldt Decision see Walt Crowley and David Wilma, "Federal Judge George Boldt Issues Historic Ruling Affirming Native American Treaty Fishing Rights on February 12, 1974."(http://www.historylink.org/index.cfm?DisplayPage=output.cfm&File_Id=5282. Accessed August 29, 2010.)

33. Burgard, 24.

34. Dale Chihuly quoted in *Chihuly: Baskets* (Seattle, Washington: Portland Press, Inc., 1994), 7.

35. Dale Chihuly, "The Indian Influences Upon My Work," in *Chihuly's Pendletons* (Seattle: Portland Press, Inc., 2000), 177.

36. LaMar Harrington, "Chihuly's Glass Creations Come Home to Tacoma," *Northwest Arts* VII, no. 13 (July 3, 1981), 8.

37. Christine Corbett, "Glass Art Shown at Museum," *The News Tribune*, Tacoma, Friday, October 9, 1981, TGIF2.

38. Cheryl Tucker, "Chihuly," *The News Tribune*, Tacoma, Thursday, September 20, 1984, B2.

39. Matt Nagle, "Wright Park Conservatory Sparkles with Chihuly Glass," *Tacoma Weekly* (November 20, 2008), C1.

40. Jen Graves, "Prince of Glass," *The News Tribune*, Tacoma, Sunday, June 30, 2002, E1+.

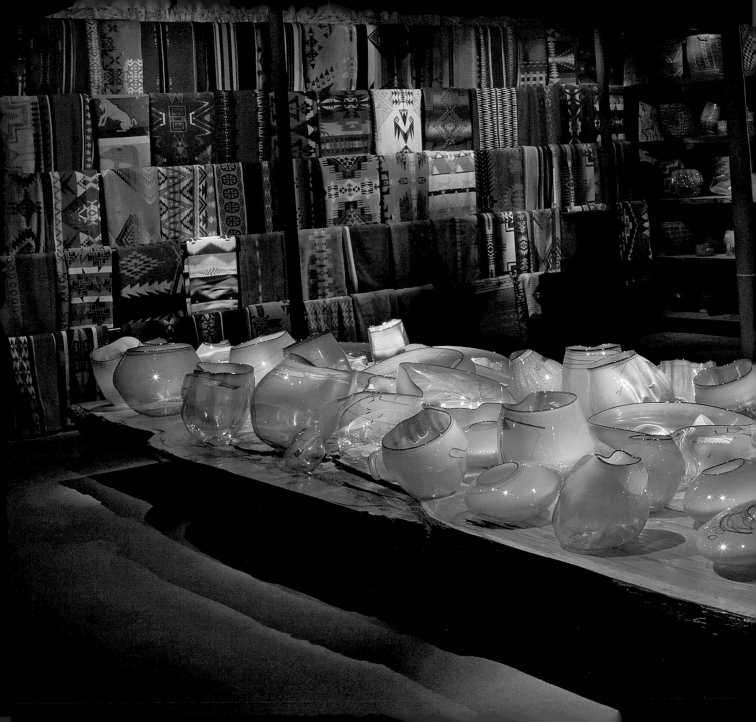

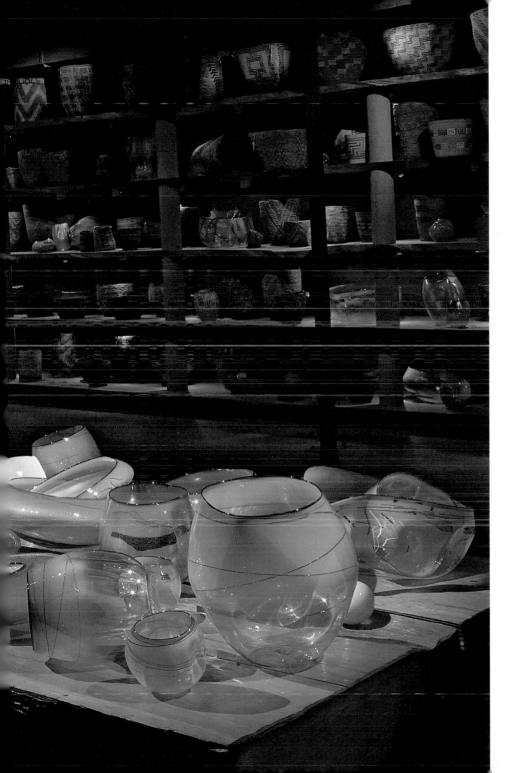

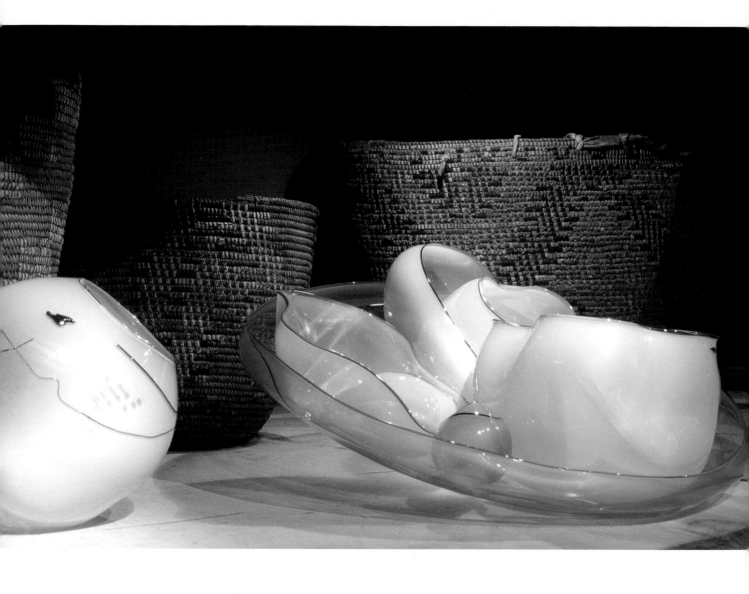

40 PREVIOUS PAGES The Northwest
Room, The Boathouse, Seattle, 2007

41 Chihuly *Basket Set* with
Native American baskets,
The Boathouse, Seattle, 2002

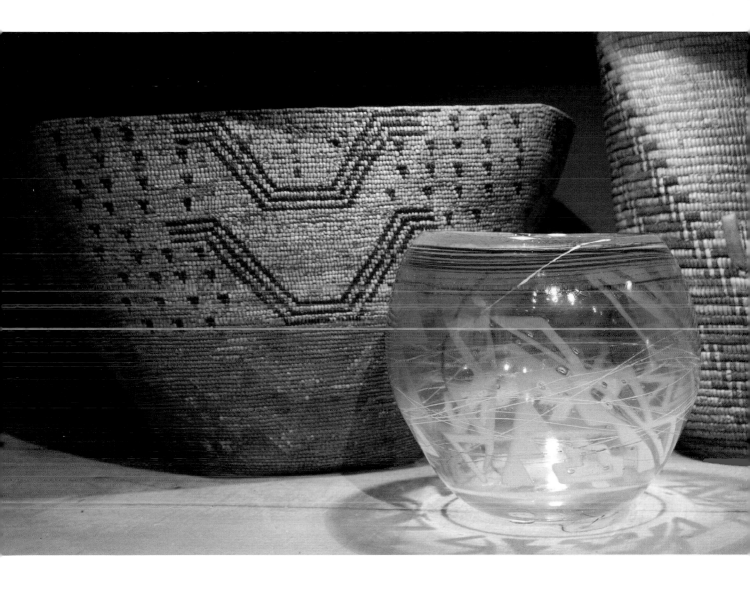

42 Chihuly *Basket* with
Native American baskets,
The Boathouse, Seattle, 2002

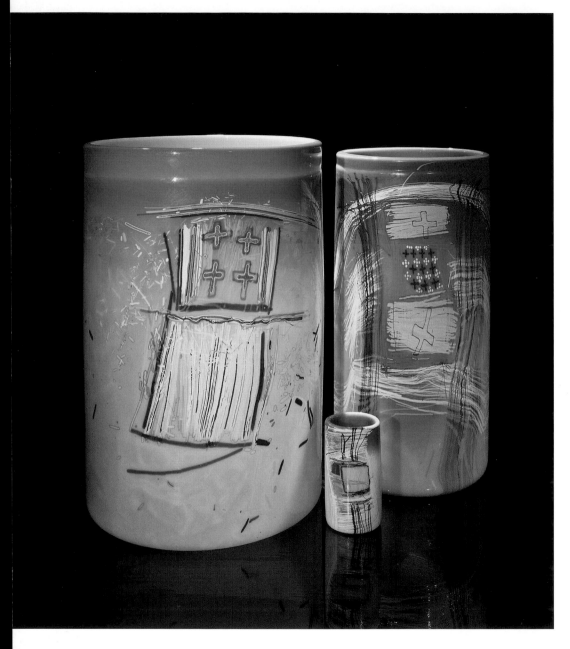

43 *Blanket Cylinder* group, 1975

44 Native American trade
 blankets, Chihuly Studio,
 Tacoma, 1999

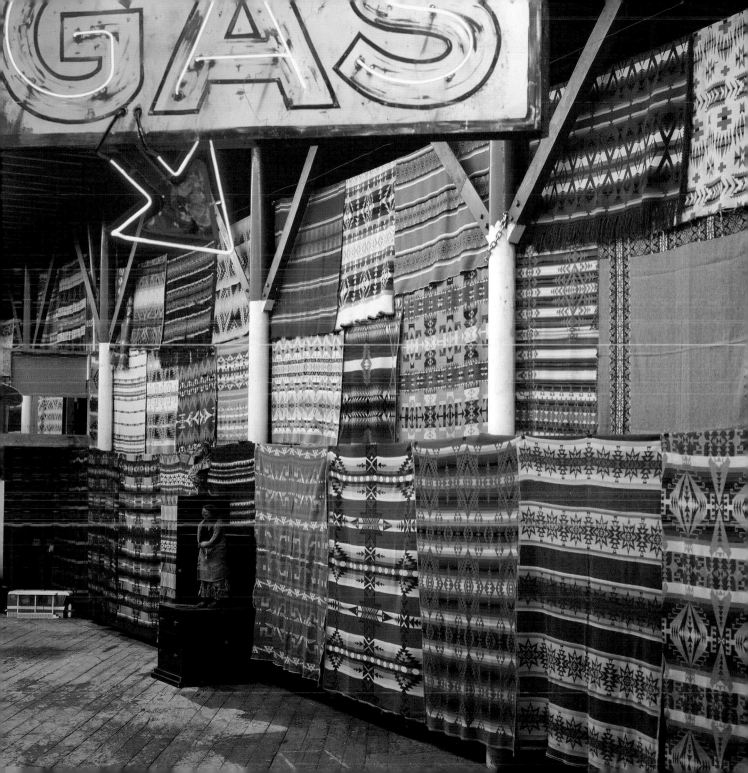

45 *Cylinder* process, Rhode Island
 School of Design, Providence, 1977

46 *Blanket Cylinder* group, 1975

47 *Indian Blanket Cylinder with Cross Blanket Drawing,* 1975, 12 x 6 x 6 inches

Untitled Cylinder, 1976, height 13 inches

48 Wool trade blankets

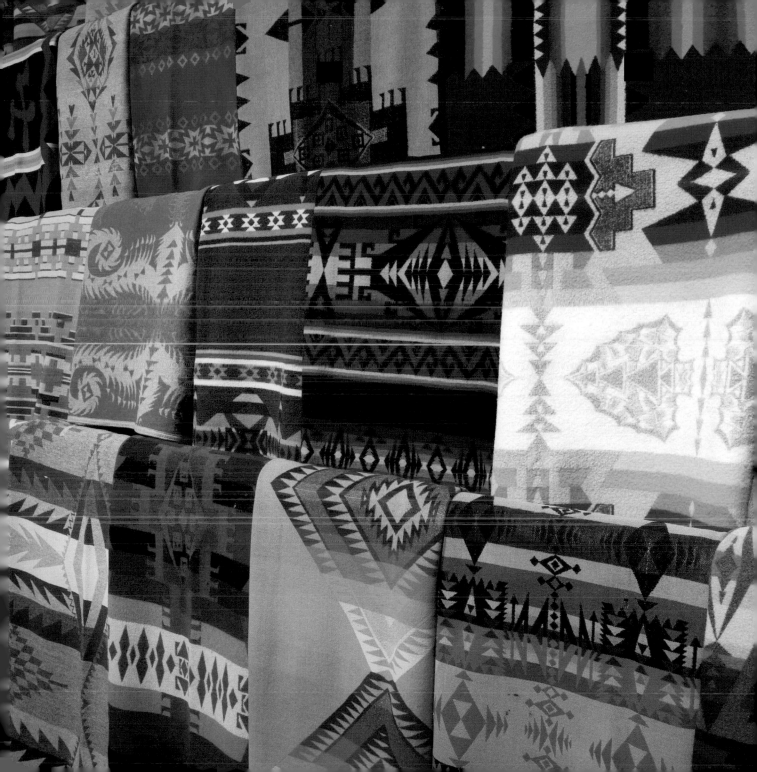

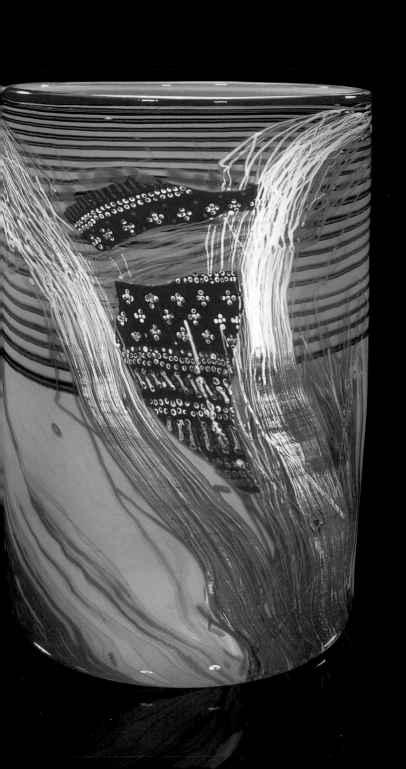

49 *Pink Cylinder with Cobalt Blue Lip Wrap*, 1984, 14 x 10 x 9 inches

50 Joey Kirkpatrick (left), Chihuly, and Flora C. Mace (right), The Boathouse hotshop, Seattle, 1993

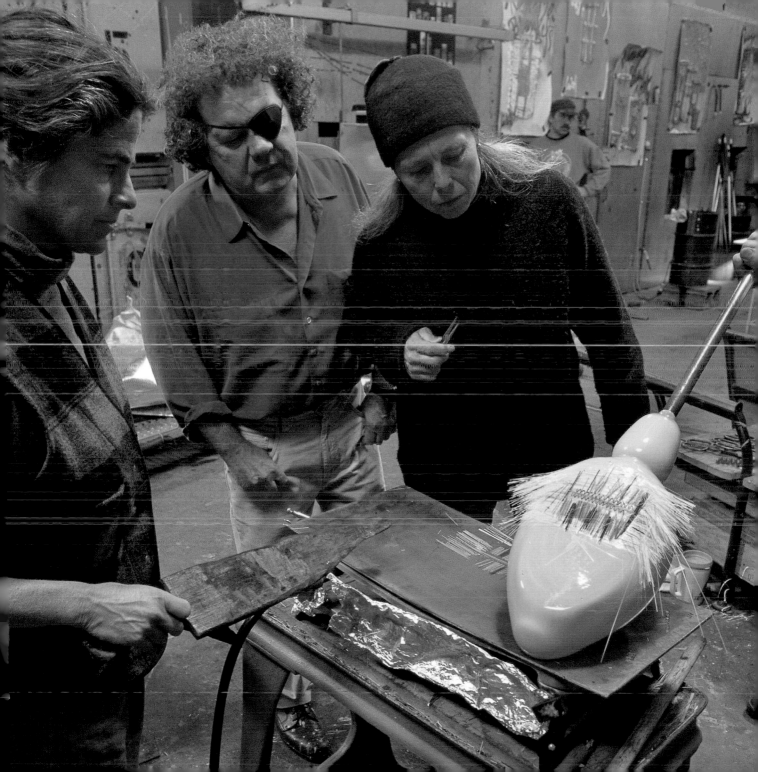

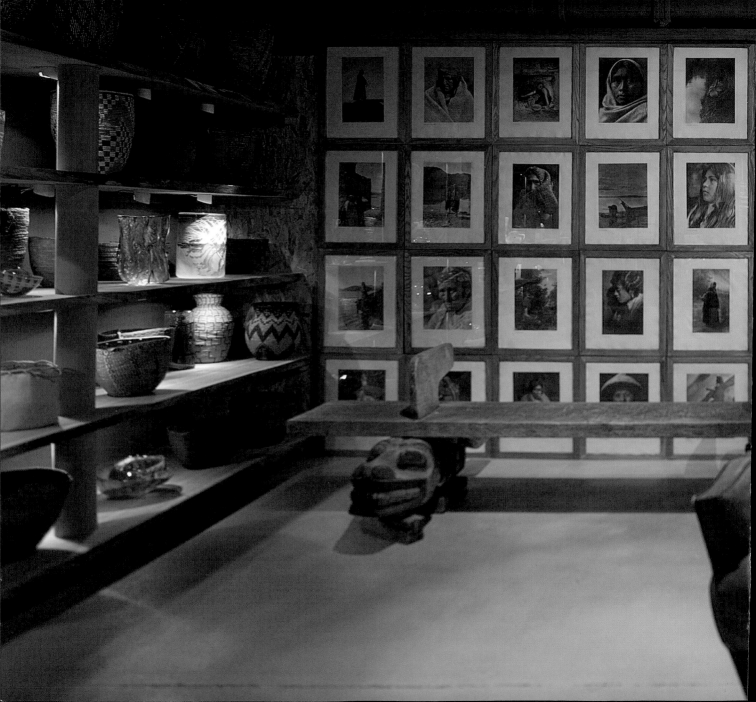

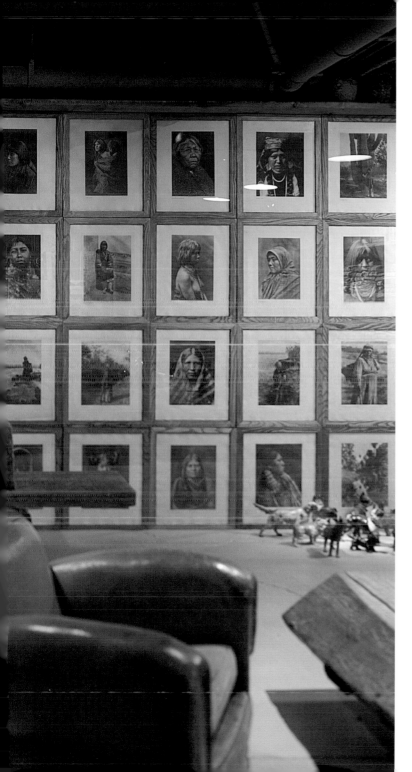

51 *Cylinder* and *Soft Cylinder* with
 Edward S. Curtis photogravures,
 Native American baskets, and
 carved bench by Duane Pasco,
 The Boathouse, Seattle

52 Installation of Native American
 carvings and baskets, 1892–1915,
 Ferry Museum, Tacoma

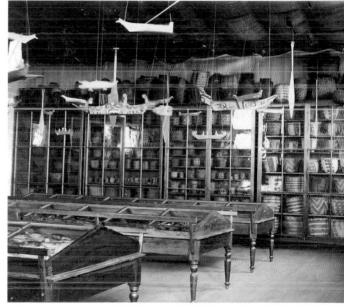

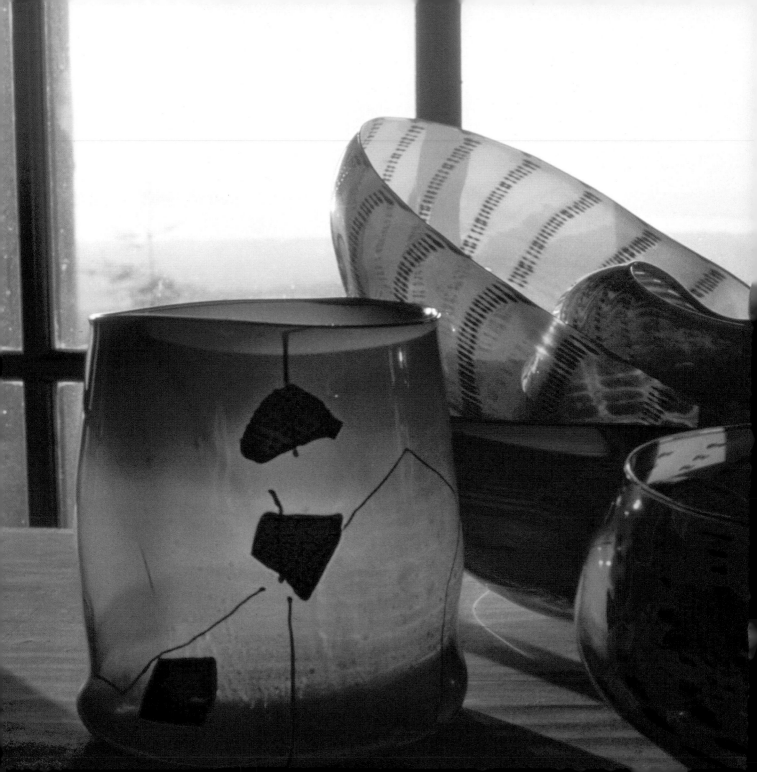

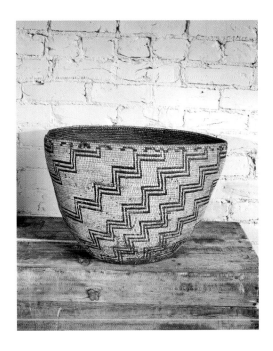

53 *Pilchuck Baskets*, Pilchuck Glass
School, Stanwood, Washington,
1980

54 Suquamish basket, Northern
Puget Sound, circa 1880,
12 x 18 x 12 inches

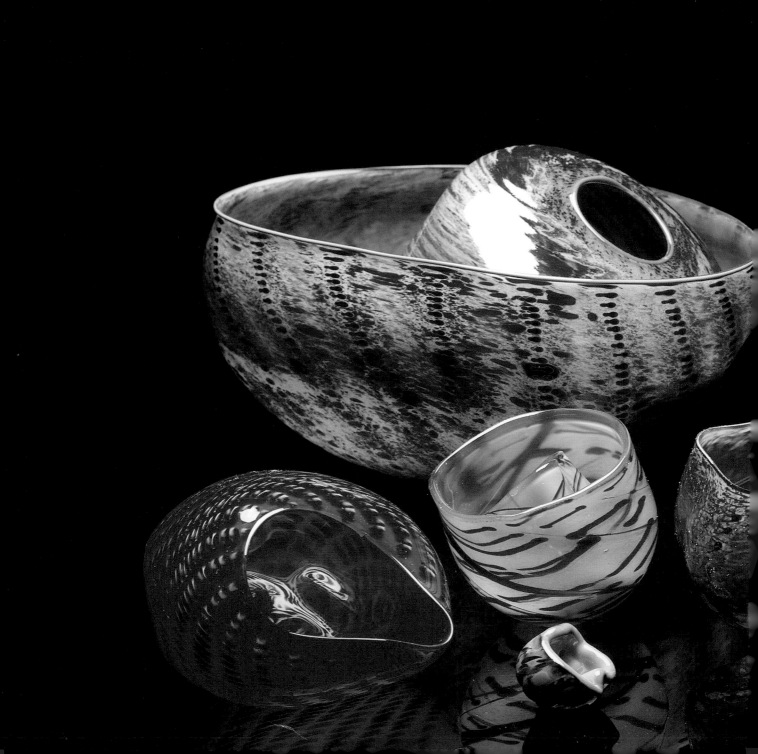

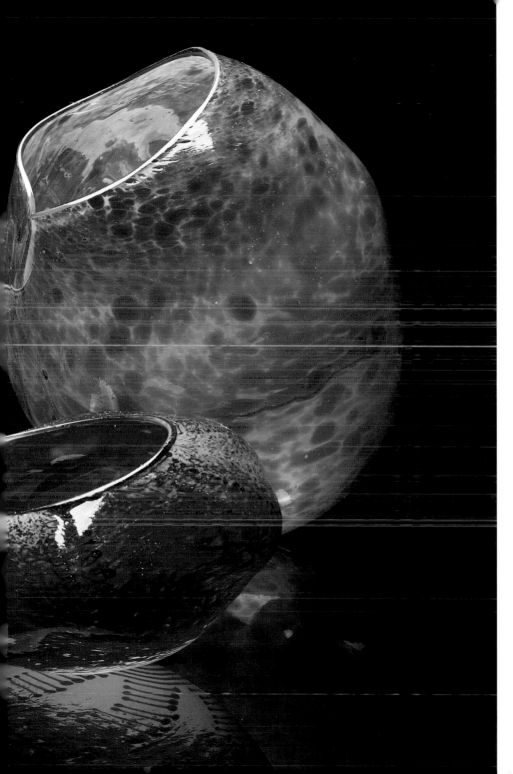

55 *Baskets / Macchia*, 1978–80
Pilchuck Glass School,
Stanwood, Washington, 1983

56 *Silver and Forest Green Pilchuck Stump*, 1992, 20 x 9 x 9 inches

57 *Pilchuck Stumps*, The Boathouse, Seattle, 1991

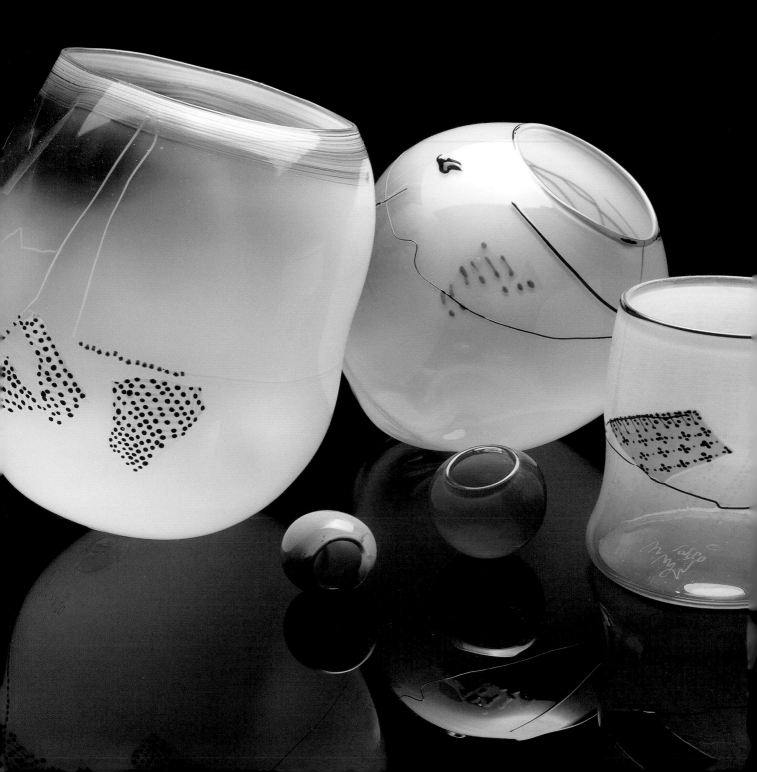

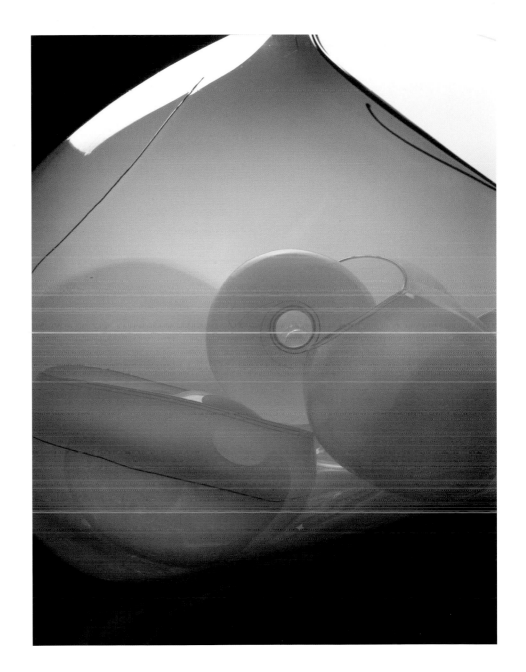

58 *Cylinders, Basket,*
1980, 8 x 15 x 15 inches

59 *Alabaster and Sky Blue*
Basket Set with Oxblood
Lip Wraps (detail), 1992,
13 x 17 x 19 inches

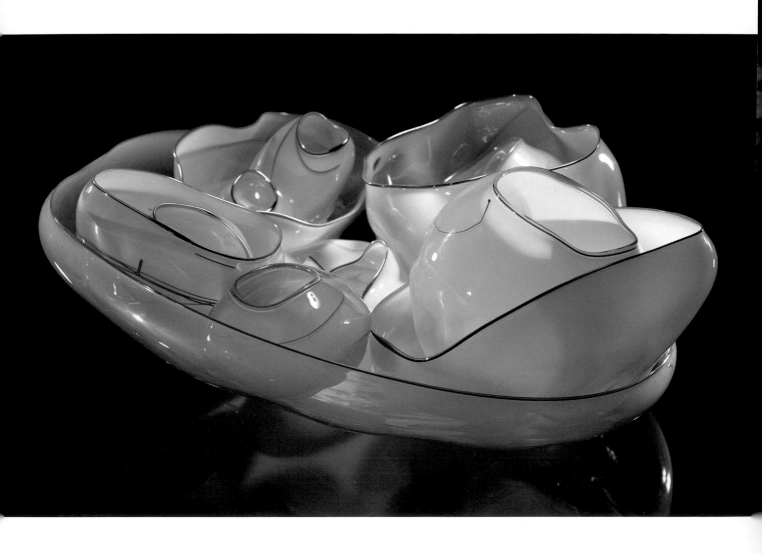

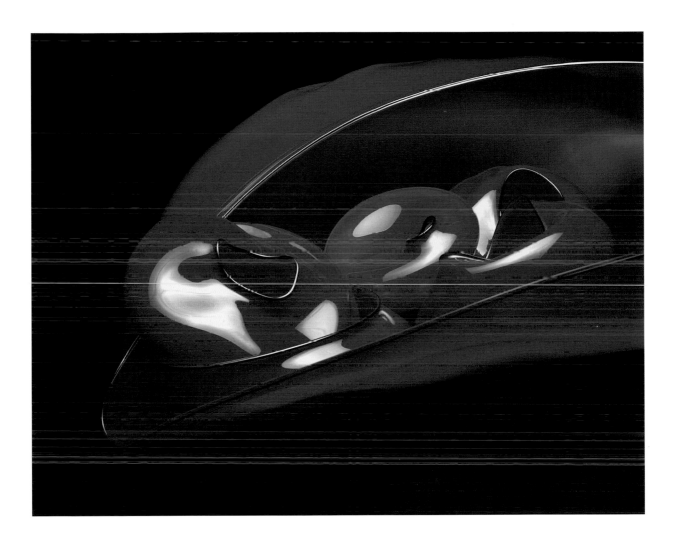

61 *Paprika Basket Set with Black Lip*
Wraps, 1993, 11 x 22 x 25 inches

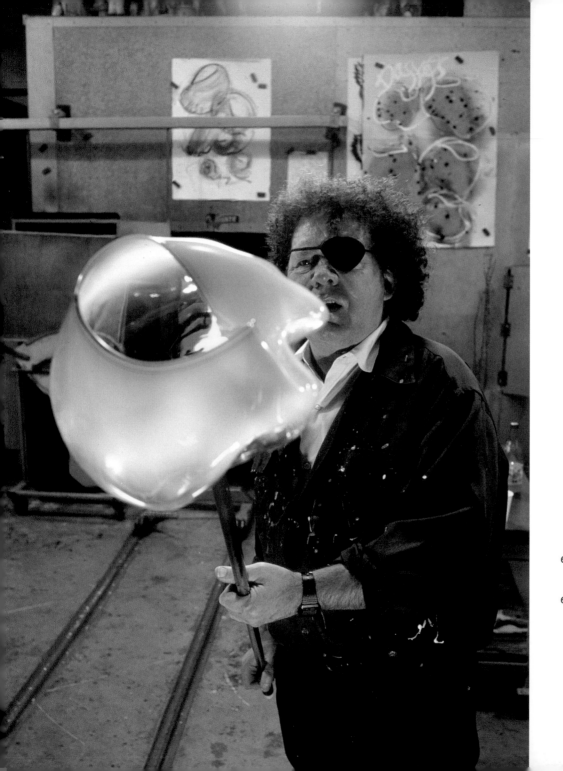

62 Dale Chihuly, The Boathouse, Seattle, 1993

63 *Alabaster Basket Set with Oxblood Lip Wraps*, 1991, 18 x 27 x 21 inches

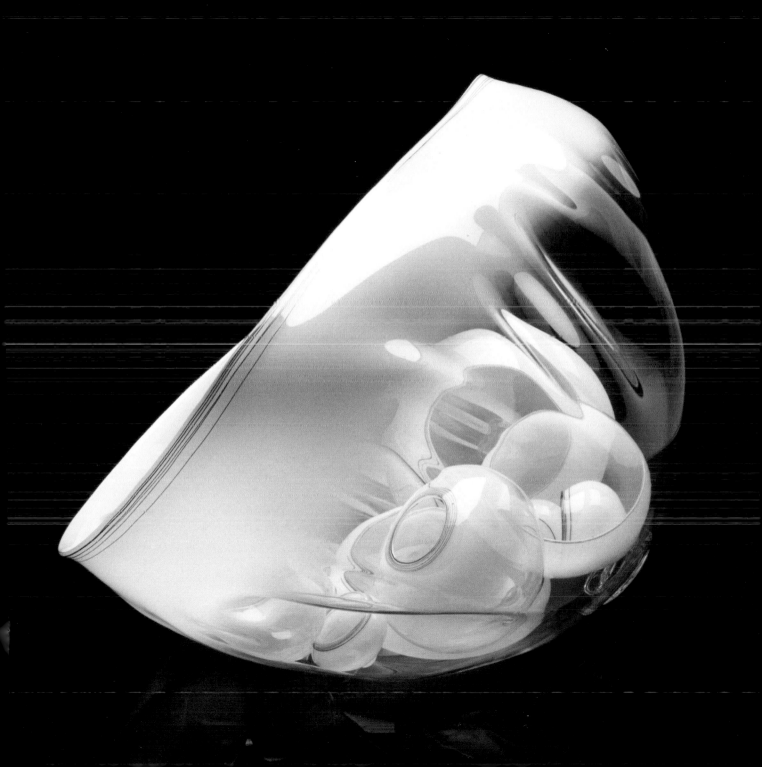

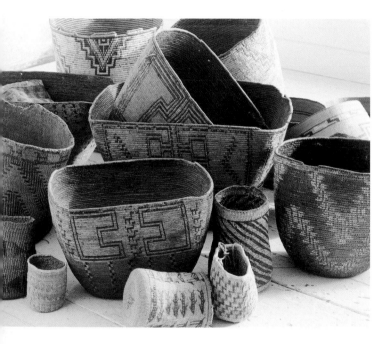

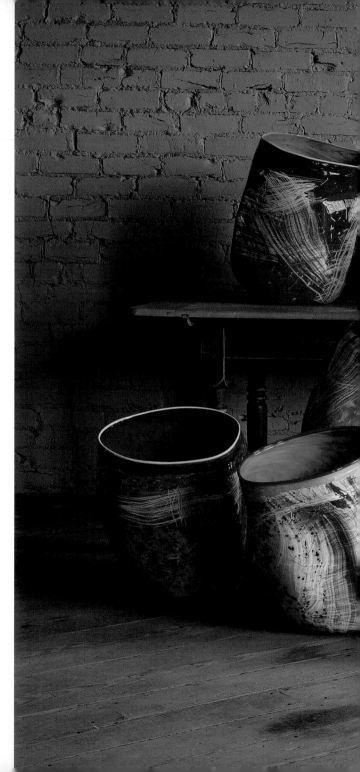

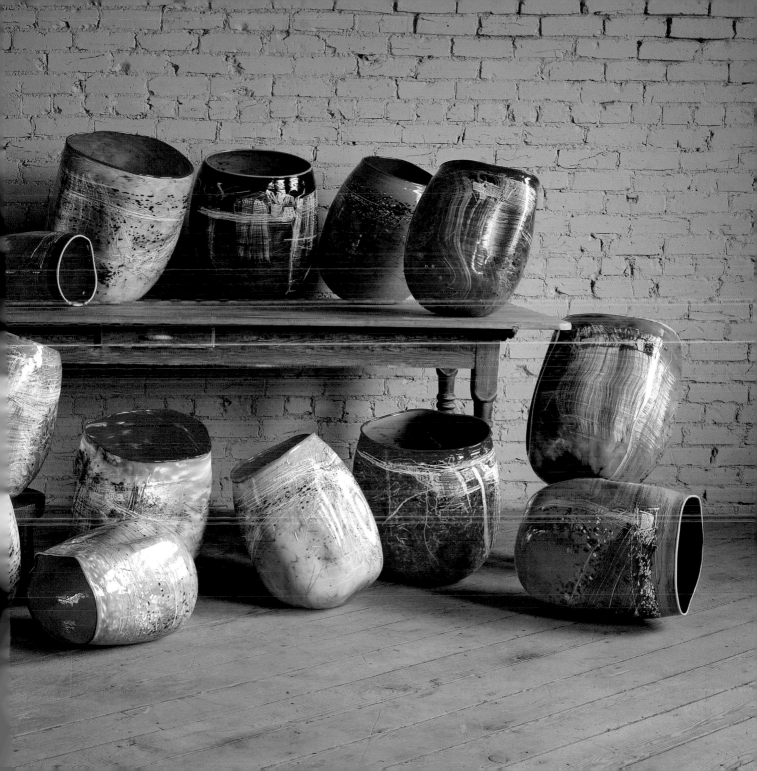

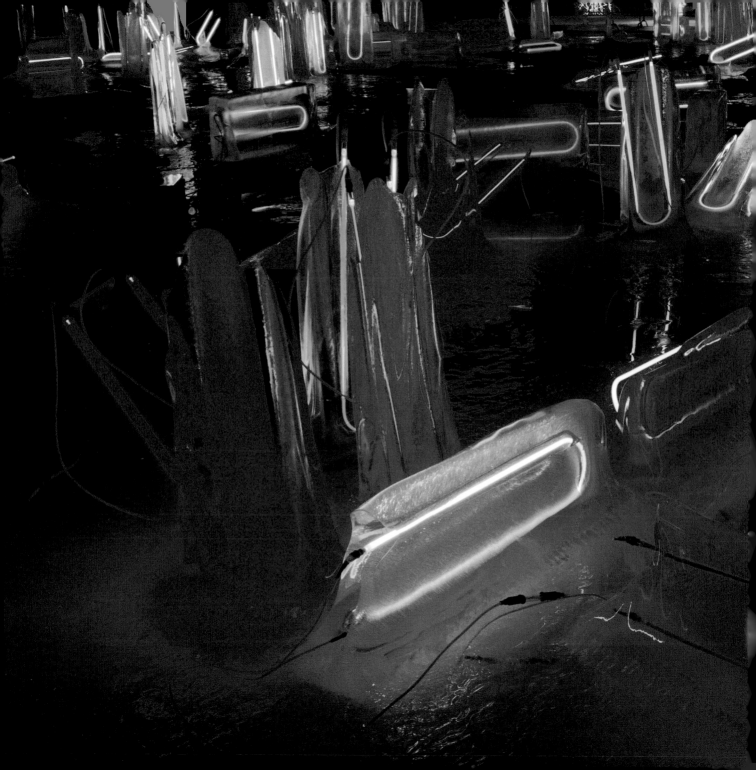

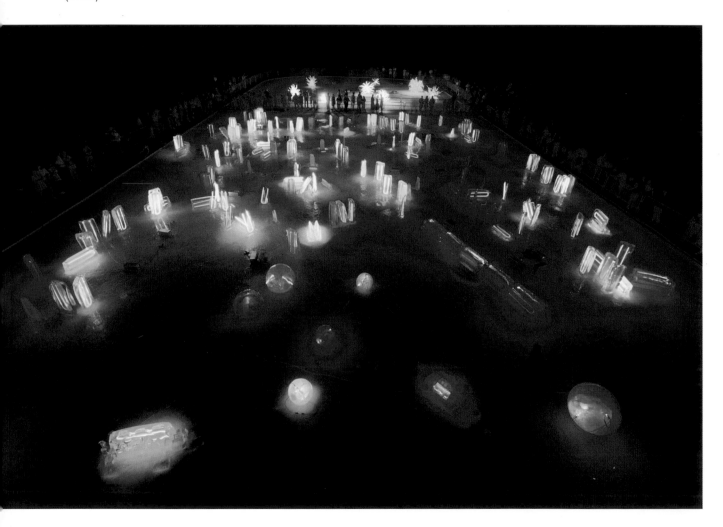

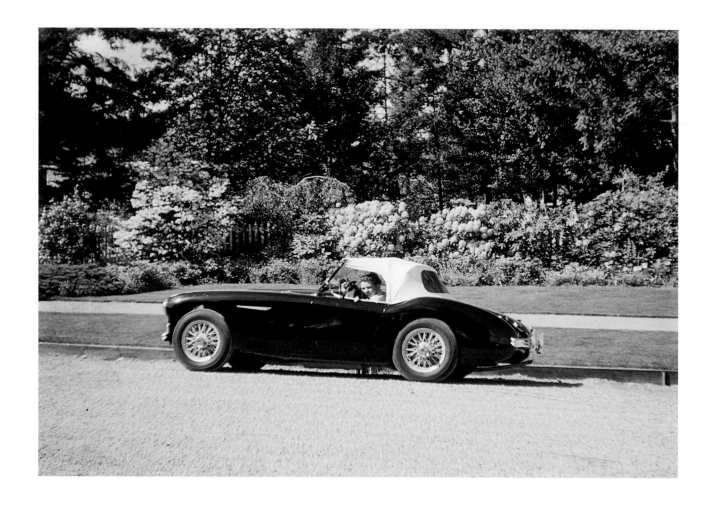

69 Dale Chihuly in his Austin-Healey, in front of his childhood home, Tacoma, 1957

70 *Venetian Group*, The Swiss Tavern, Tacoma, 1994

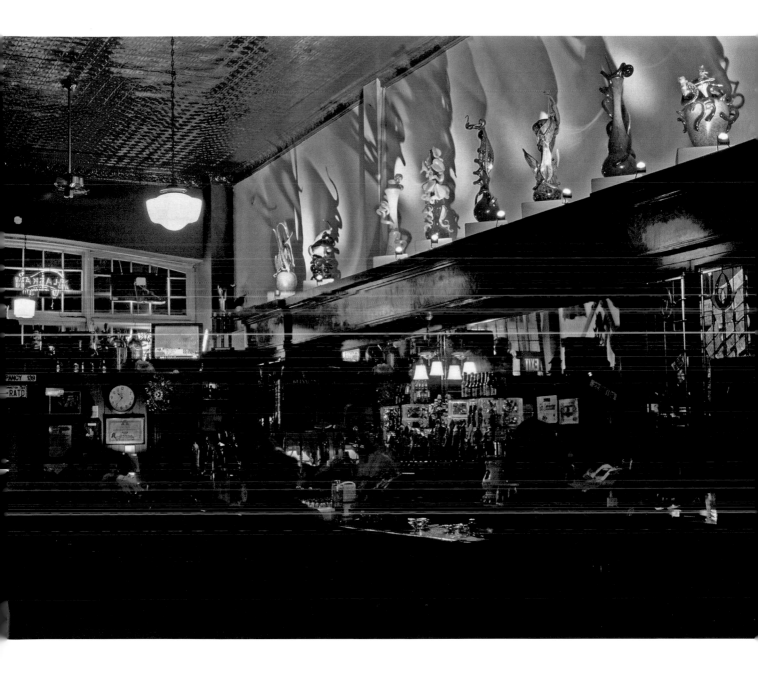

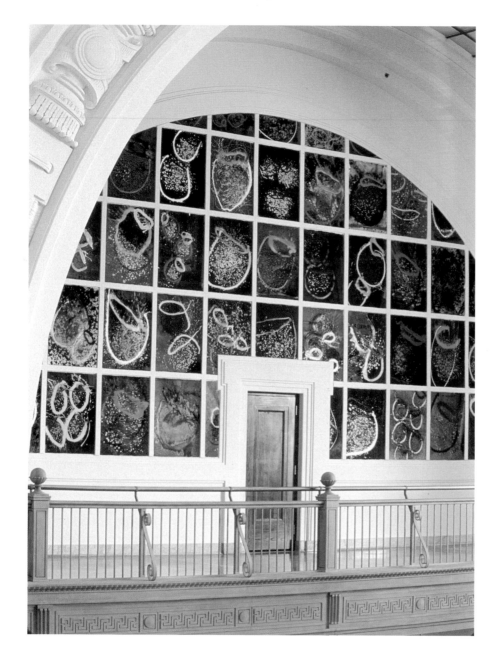

71 *Basket Mural*, acrylic on paper, Union Station, Tacoma, 22 x 40 feet, 1994

72 Installation of *Cobalt Blue Chandelier*, Union Station, Tacoma, 1994

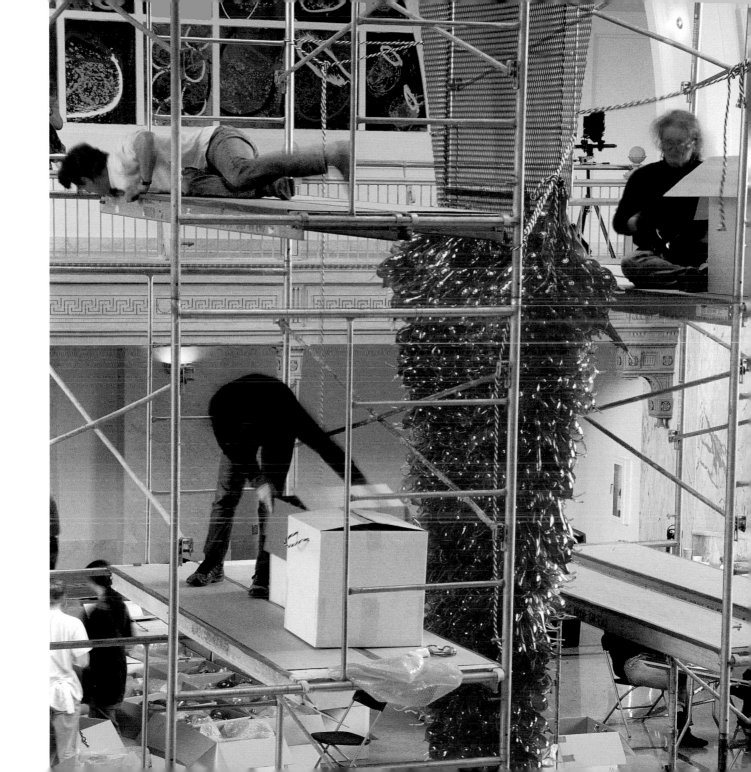

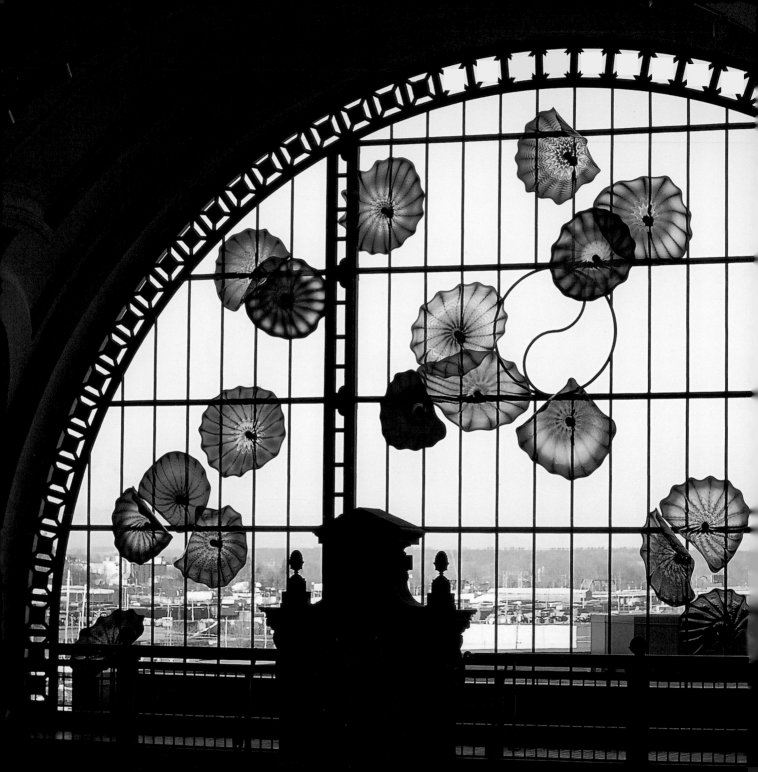

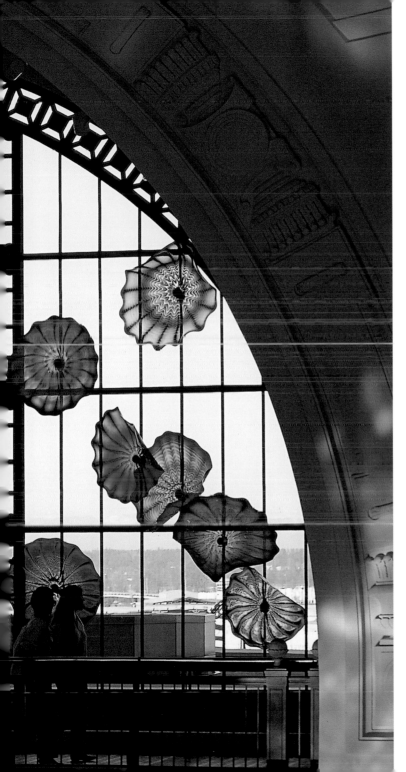

73 *Monarch Window*, 22 x 40 x 3 feet,
 Union Station, Tacoma, 1994

74 Chihuly inspecting
 Monarch Window

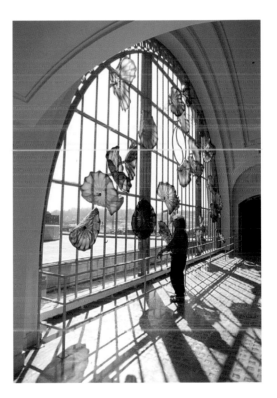

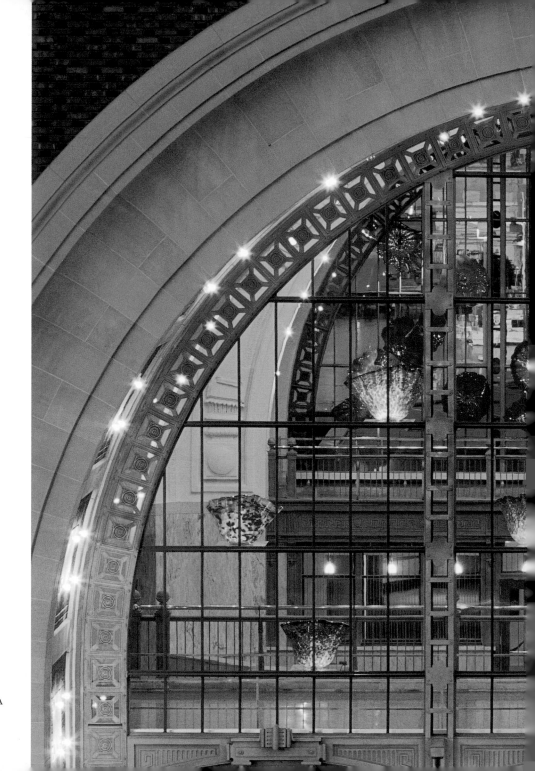

75 *Macchia Window, Cobalt Blue Chandelier*, and *Monarch Window*, Union Station, Tacoma, 1994

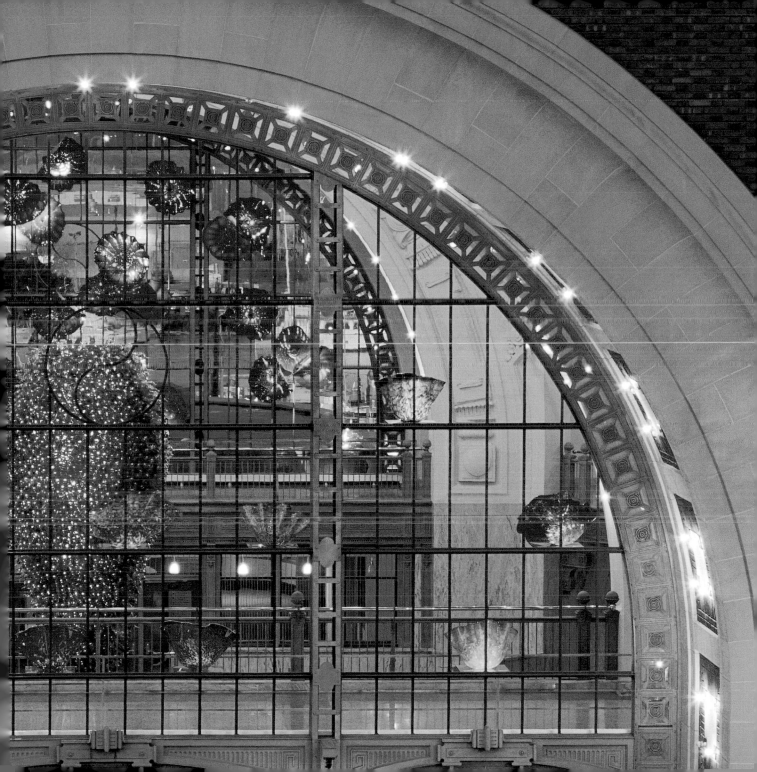

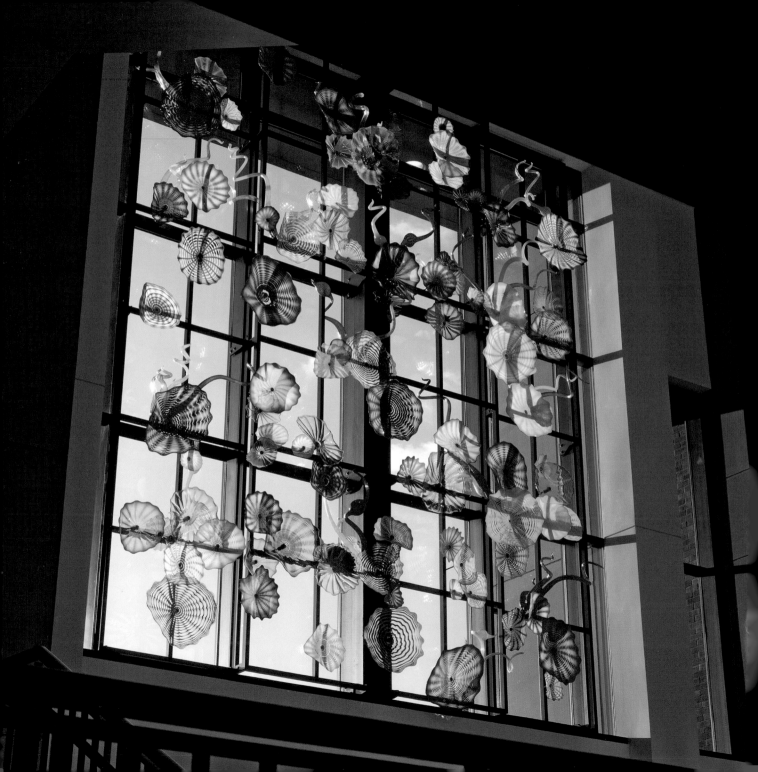

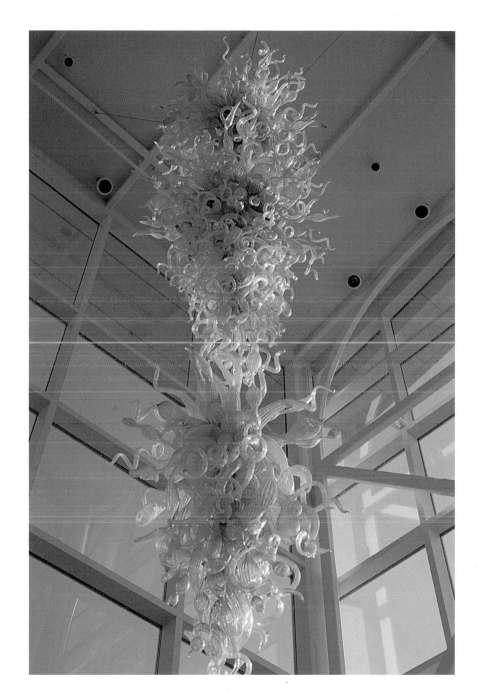

76 *The Chihuly Window*, University of Puget Sound, Tacoma, 2000, 19½ x 17 feet

77 *Kelso's Beacon*, The News Tribune Building, Tacoma, 1997, 22 x 6 x 6 feet

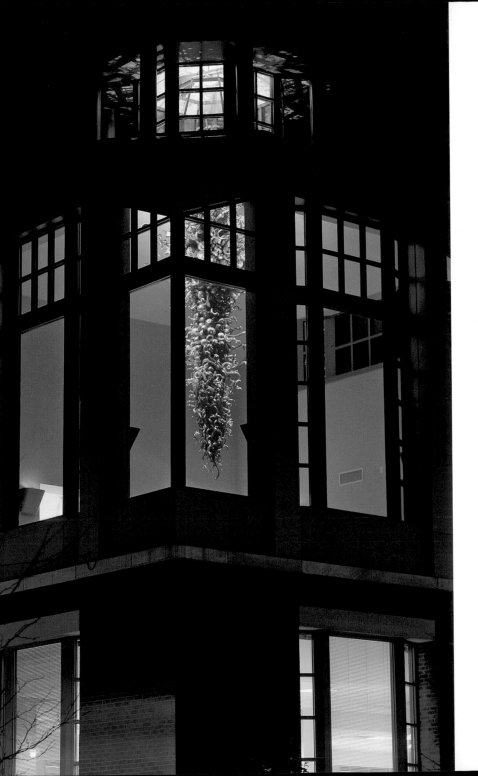

78 *Chinook Red Chandelier*, University of Washington Library, Tacoma, 1999, 21 x 8 feet

79 *Persian Installation*, Frank Russell Company, Tacoma, 1988

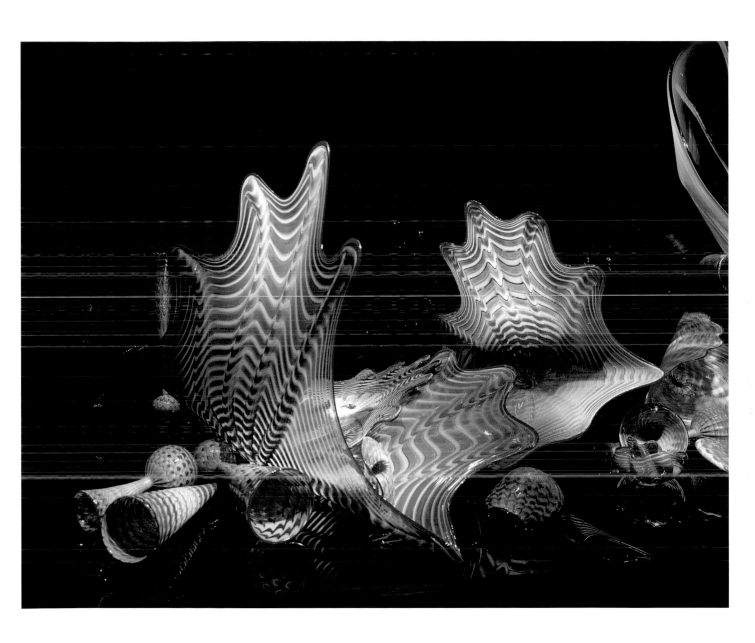

80 *Chihuly Bridge of Glass* with
Crystal Towers, Tacoma, 2002

FOLLOWING PAGES

81 *Chihuly Bridge of Glass, Seaform
Pavilion*, Tacoma, 2002

82 *Chihuly Bridge of Glass, Venetian
Wall*, Tacoma, 2002

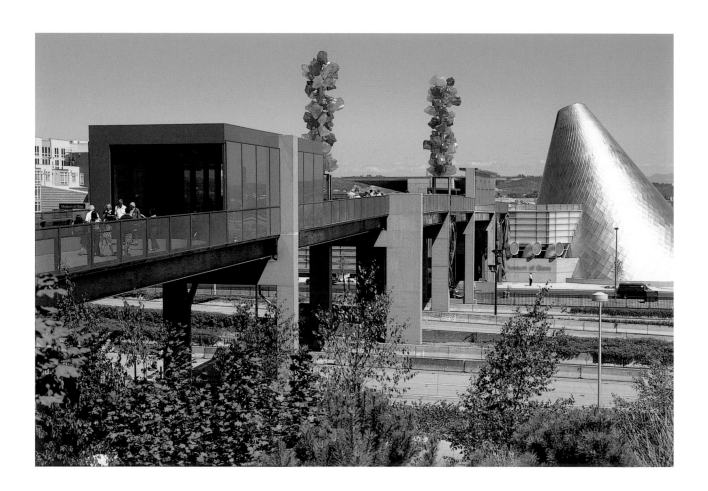

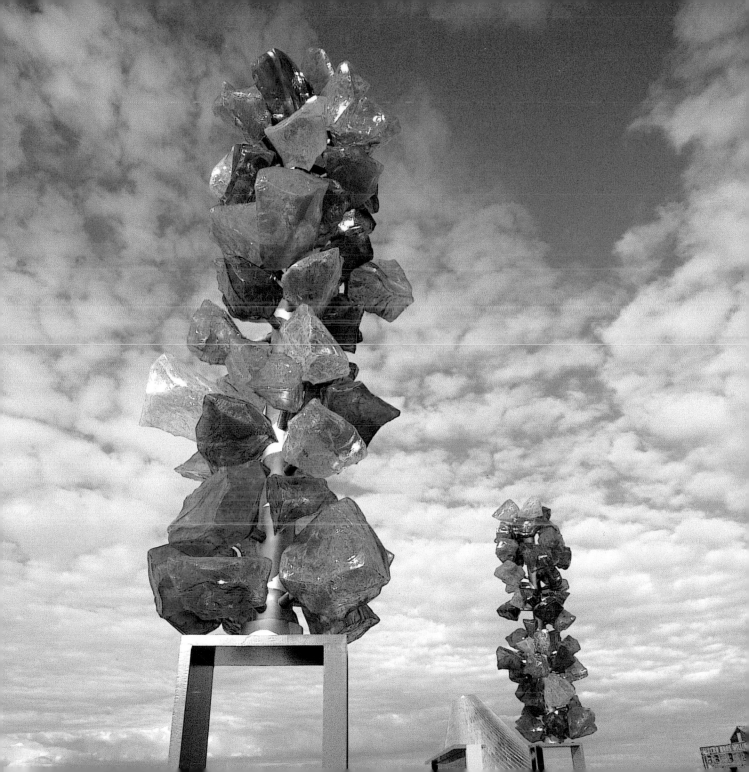

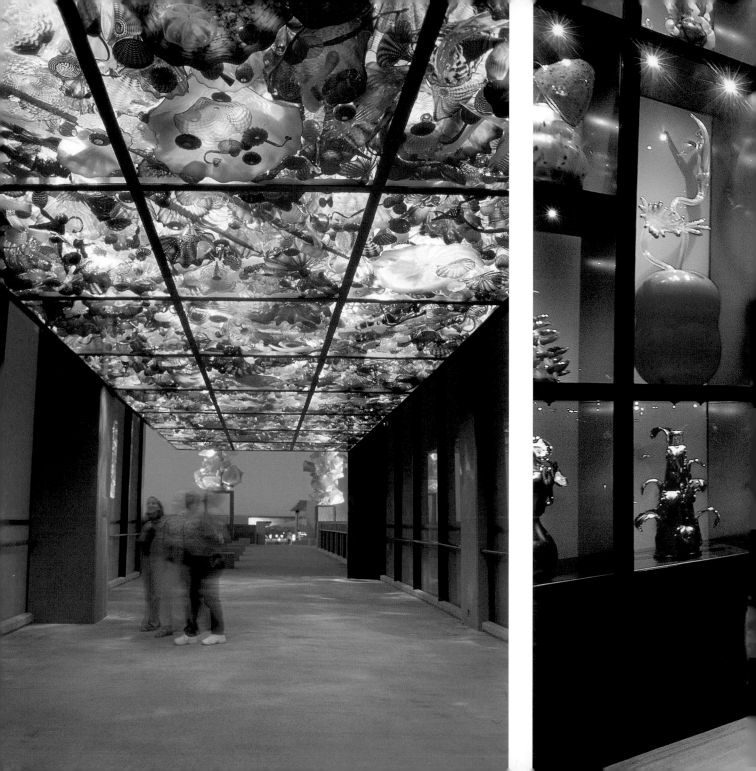

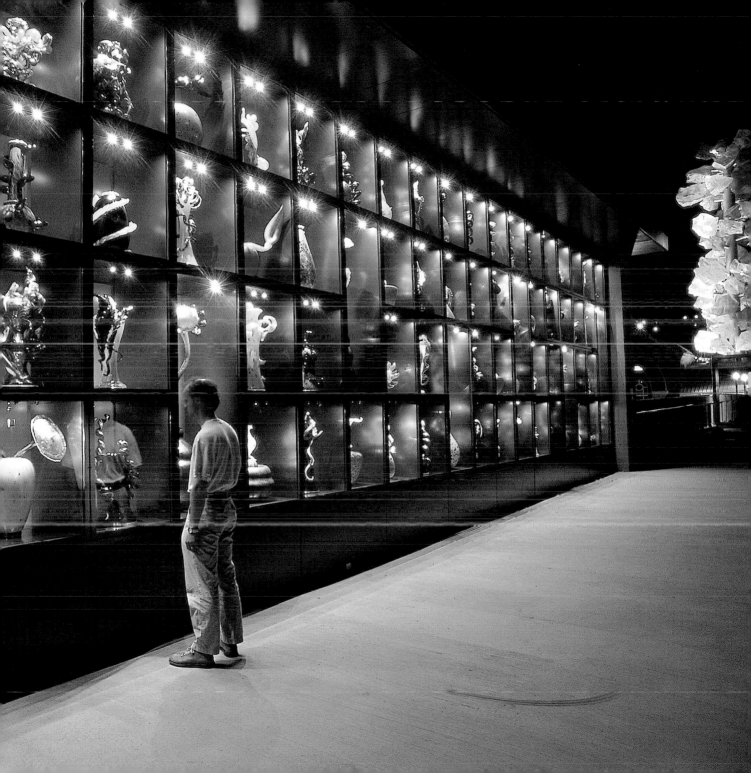

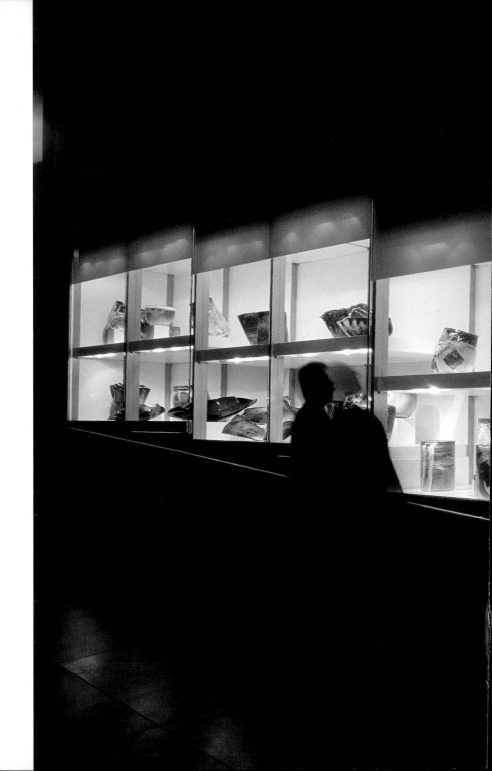

83 Dale Chihuly Collection, Tacoma Art Museum, 2003

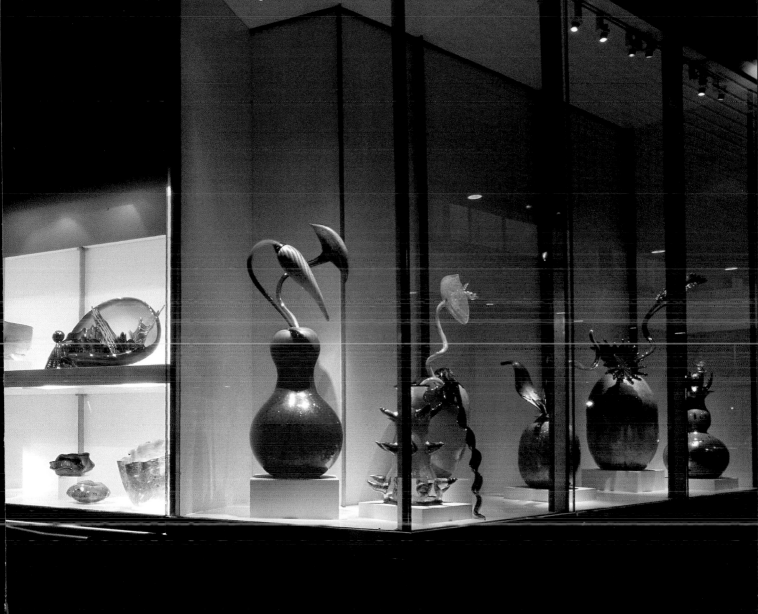

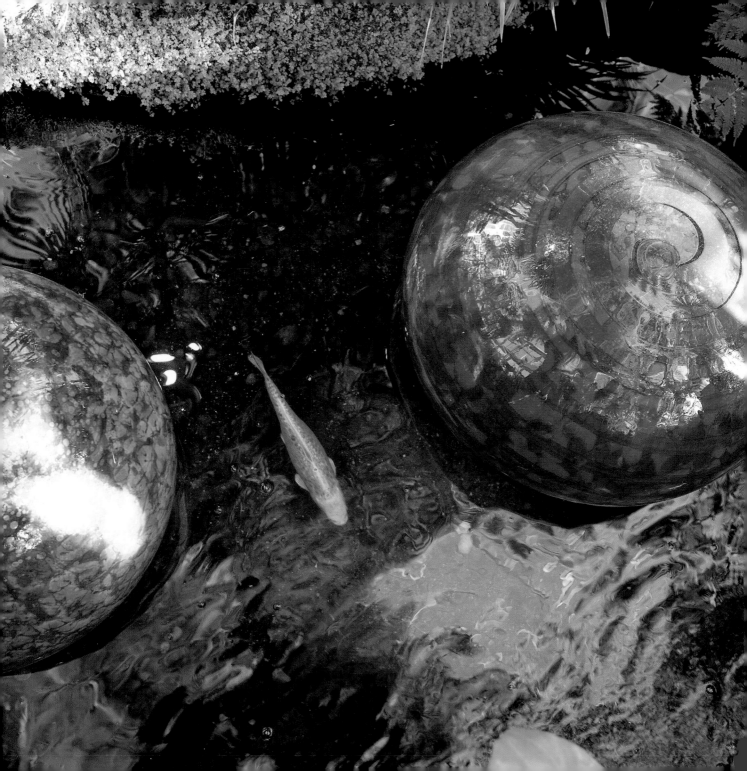

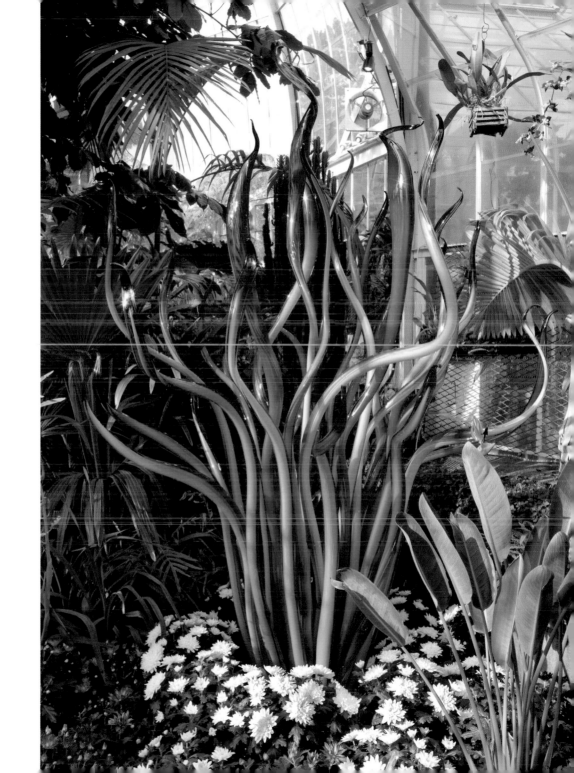

84 *Niijima Floats*, 2008,
W. W. Seymour Botanical
Conservatory, Tacoma

85 *Cattail Fiori*, 2008,
8 x 5 x 5½ feet,
W. W. Seymour Botanical
Conservatory, Tacoma

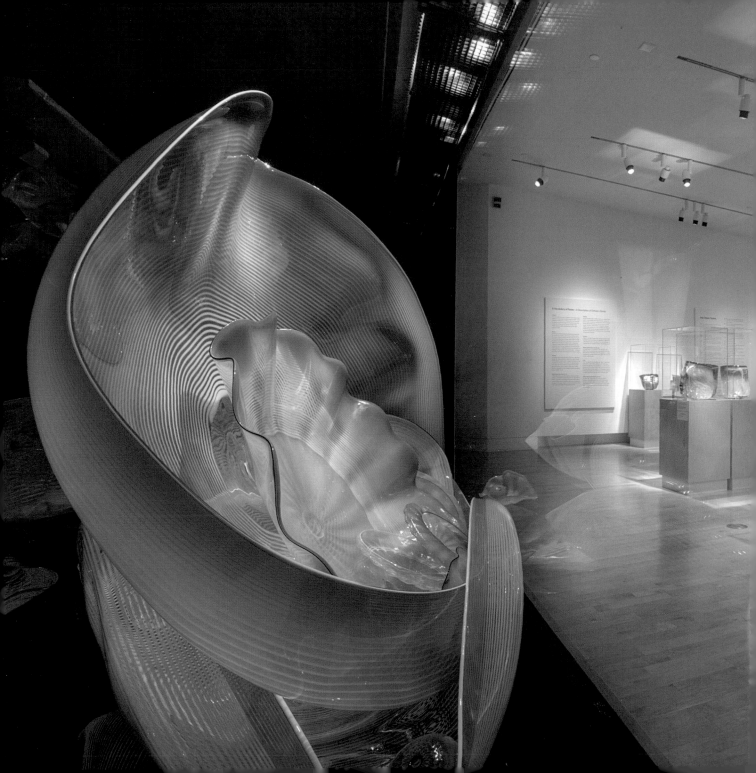

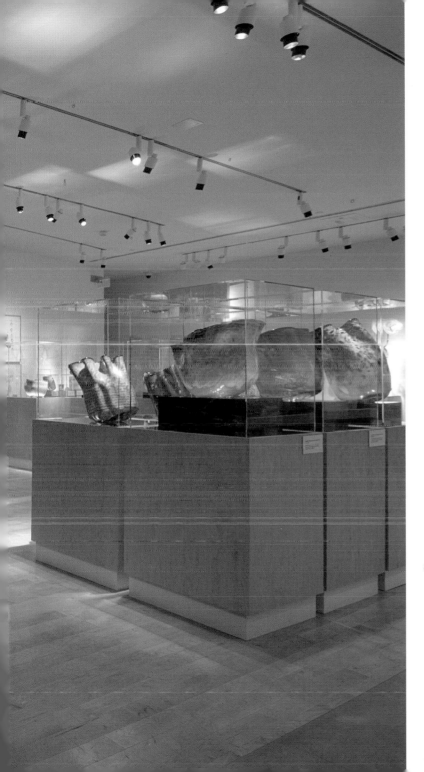

86 The newly installed *Chihuly: Gifts from the Artist* exhibition, 2010

NOTE: Plates 87–99 show gifts from the artist in honor of his parents, Viola and George, and his brother, George W. Chihuly

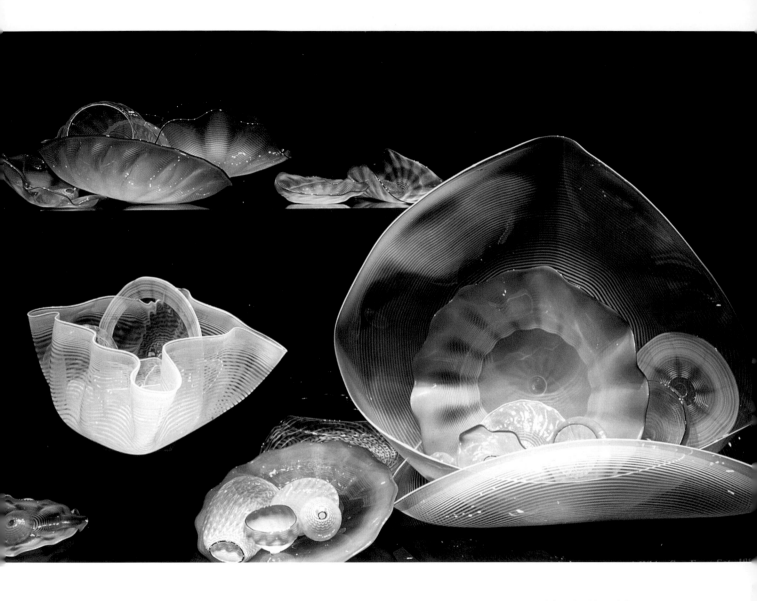

87 *Pink and White Seaform Set,*
1981–87, 36 x 60 x 29 inches

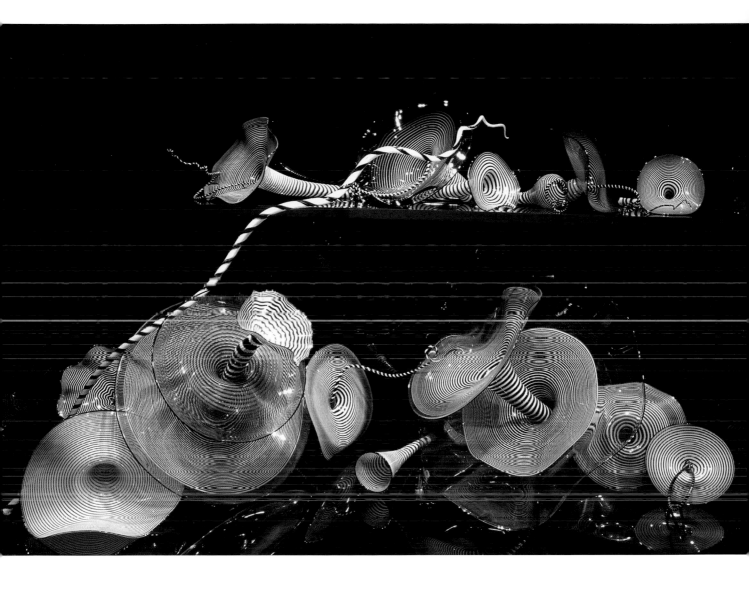

88 *Carmine and White Flower Set,*
1987, 36 x 60 x 29 inches

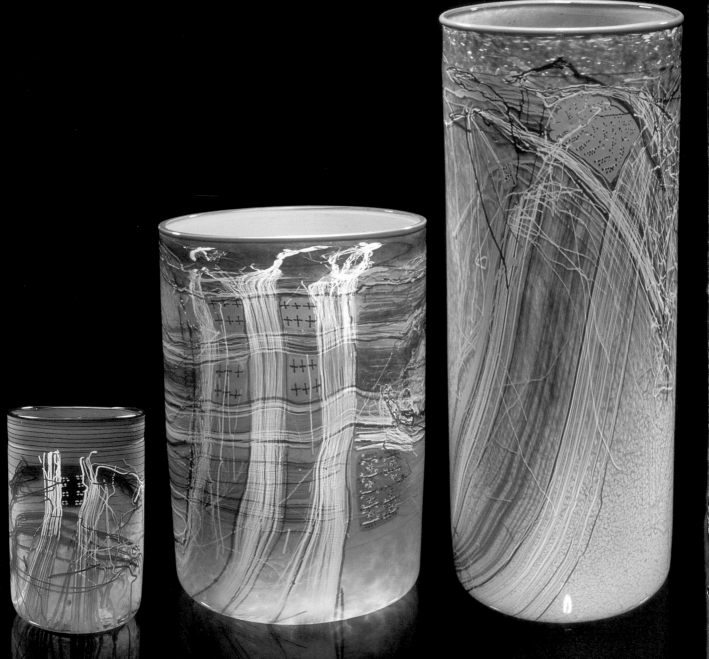

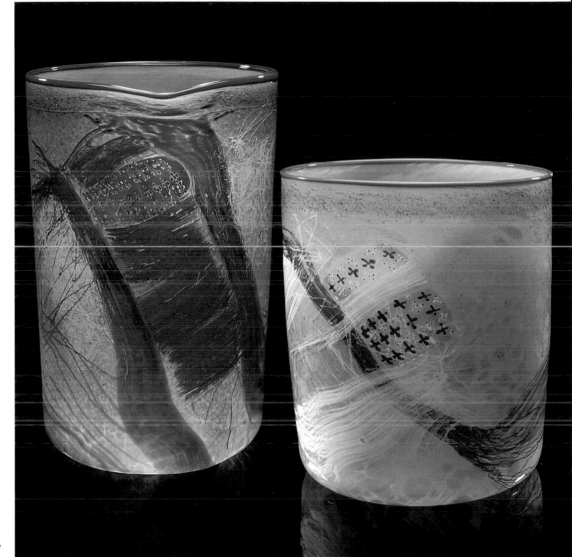

89 OPPOSITE, LEFT TO RIGHT *Windsor Green Cylinder with Cobalt Violet Drawing*, 1984, 6 x 4 x 4 inches

Chromium Cylinder with Cobalt Violet Drawing, 1984, 14 x 10 x 10 inches

Cobalt Violet Cylinder with Naples Yellow Drawing, 1984, 18 x 7 x 7 inches

90 *Apricot Cylinder with Grayed Blue Drawing*, 1984, 14 x 9 x 8 inches

Peach Cylinder with Drawing, 1985, 12 x 10 x 10 inches

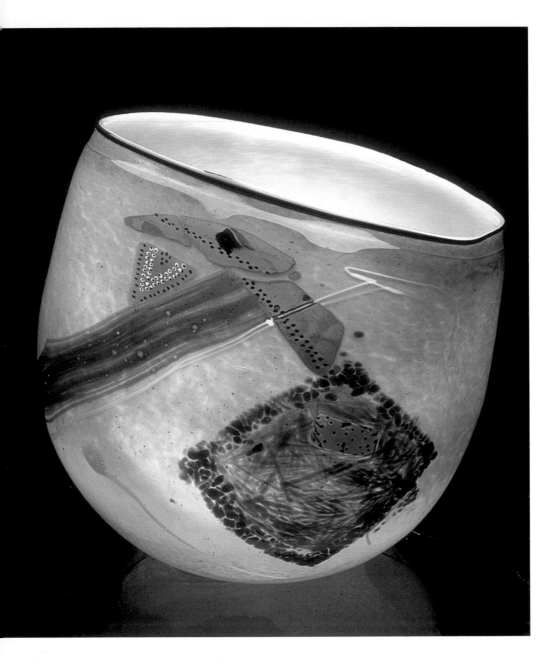

91 *Turquoise Blue Soft Cylinder with Rose Madder Drawing,* 1984, 10 x 10 x 9 inches

92 *Oxblood Soft Cylinder with Payne's Gray Drawing,* 1984, 11 x 13 x 10 inches

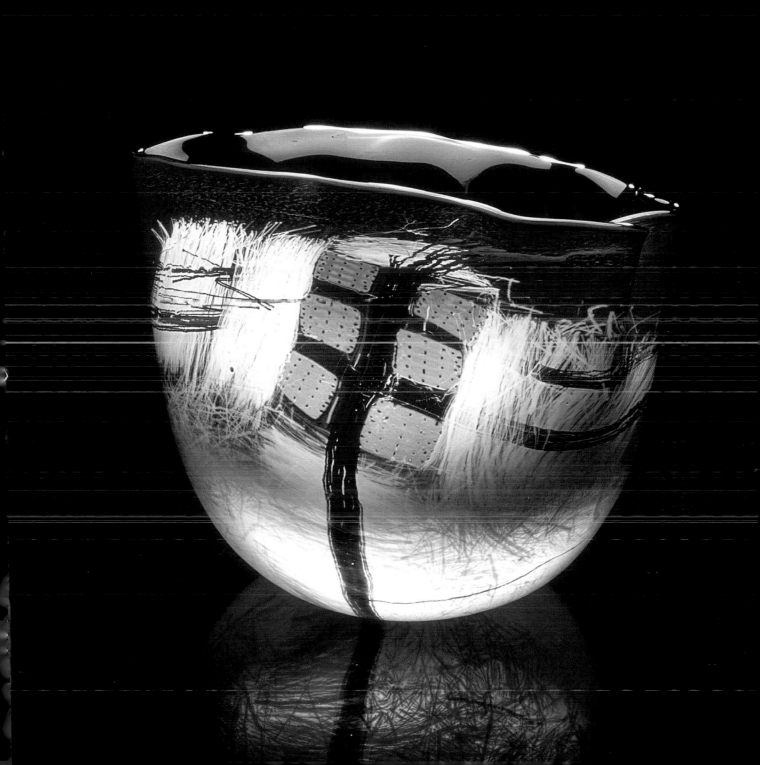

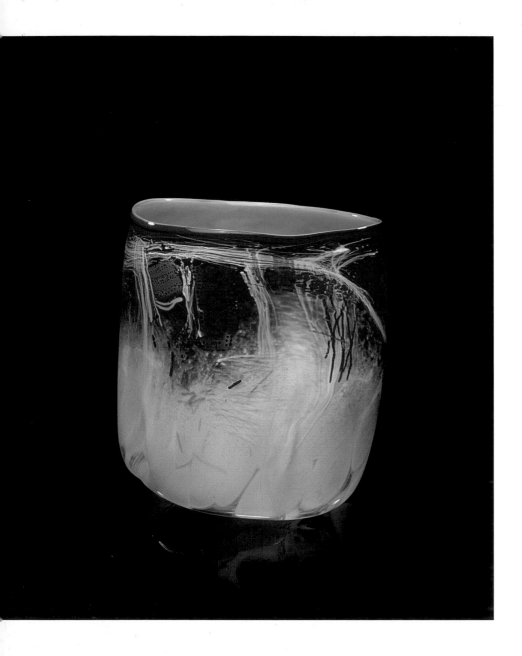

93 *Cerulean Blue Soft Cylinder with Lavender Alizarin Drawings*, 1986, 10 x 10 x 9 inches

94 *Purple Lake Soft Cylinder with Alizarin Drawing*, 1986, 15 x 15 x 13 inches

Cadmium Red Soft Cylinder with Burnt Umber Drawing, 1986, 15 x 11 x 11 inches

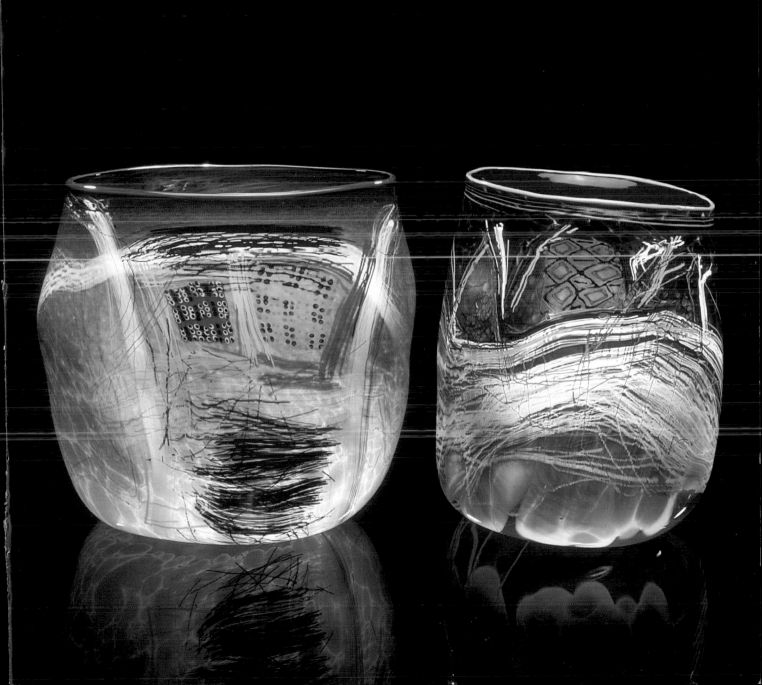

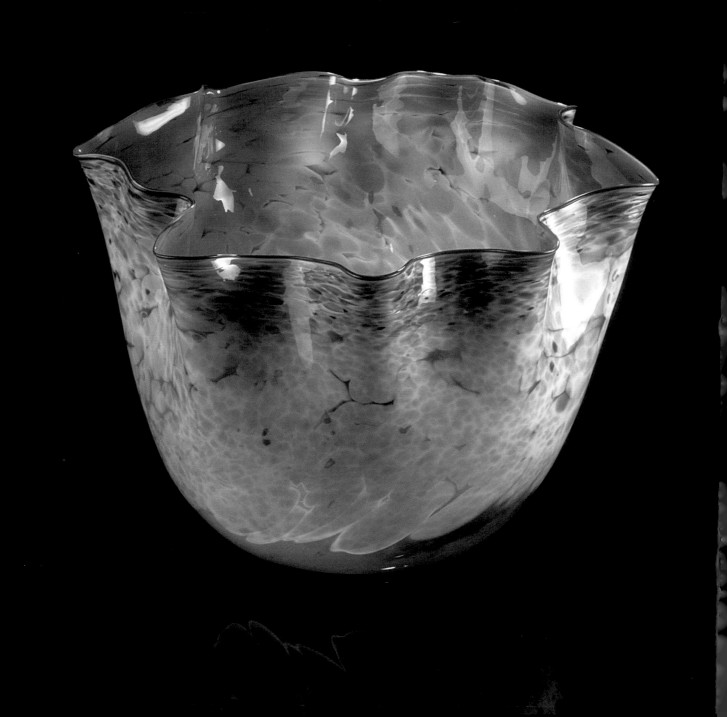

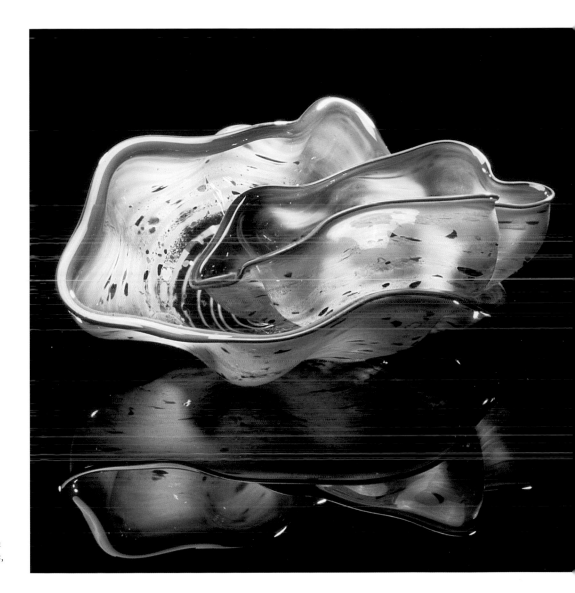

95 *Rose Madder Macchia with Jade Lip Wrap*, 1985, 15 x 18 x 17 inches

96 *Delft Blue Macchia Pair with Cadmium Orange Lip Wraps*, 1987, 6 x 14 x 8 inches

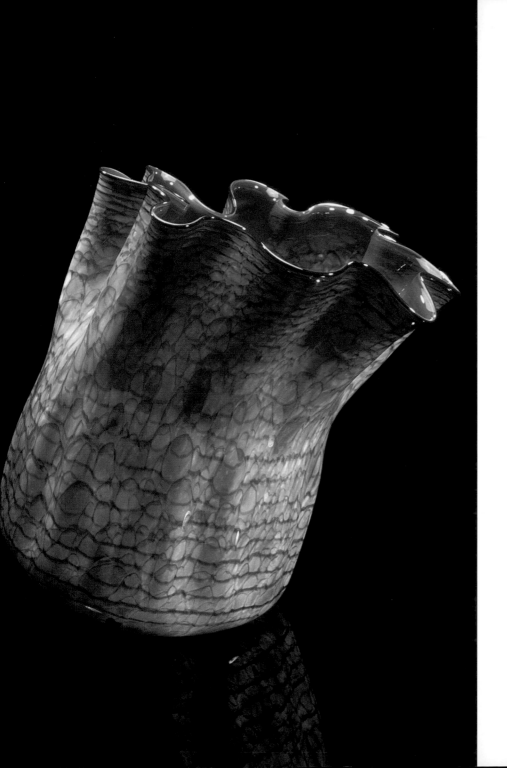

97 *Permanent Mauve Macchia
with Ultramarine Lip Wrap,*
1986, 17 x 15 x 15 inches

98 *Sap Green Macchia with
Cobalt Lip Wrap,* 1985,
22 x 14 x 14 inches

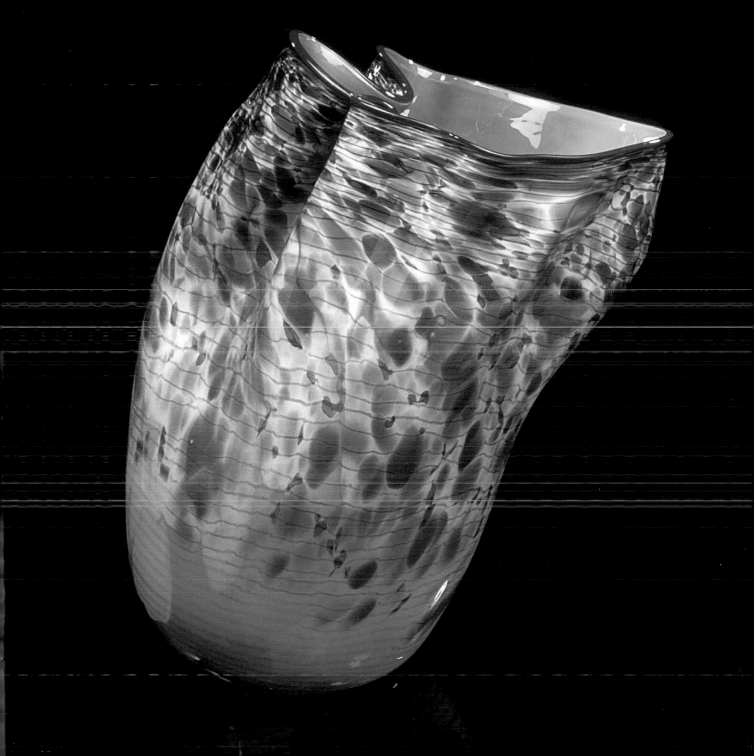

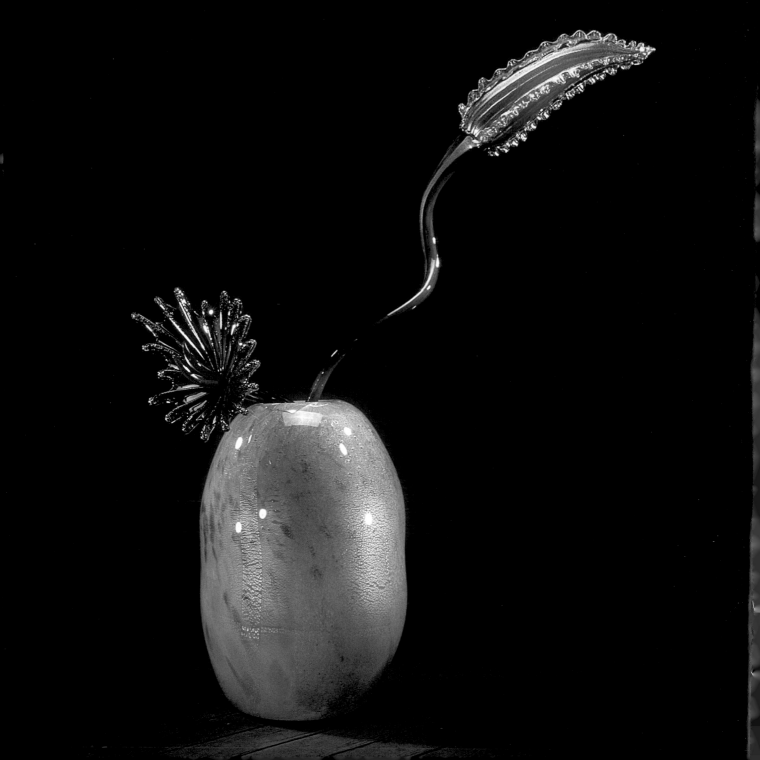

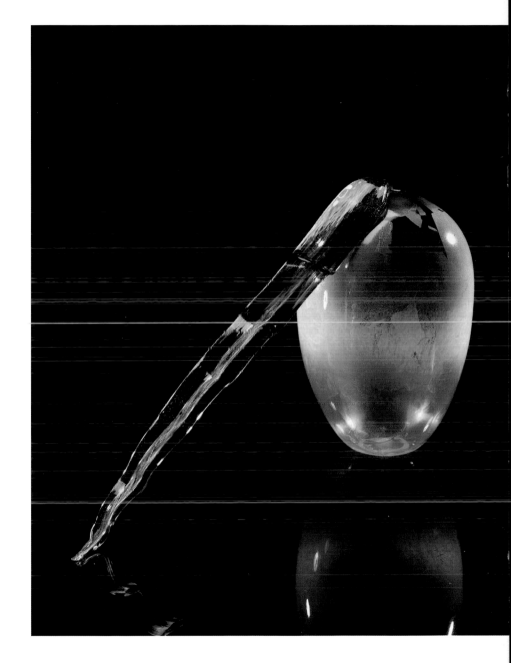

99 *Stippled Ice Blue and Green Ikebana with Purple and Cyan Stems*, 2002, 60 x 48 x 17 inches

100 *Chartreuse and Clear Orange Ikebana with Cerulean Stem*, 1993, 27 x 48 x 17 inches, Gift of the family of Brian F. Dammeier

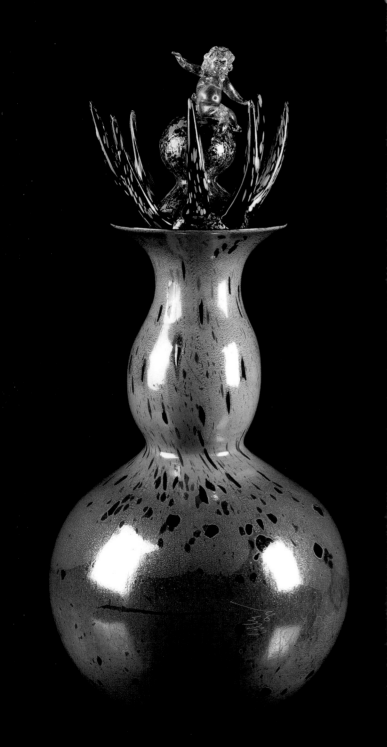

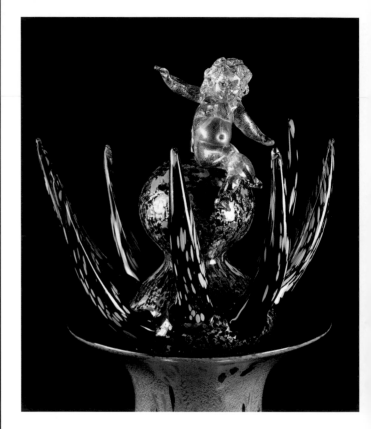

101 *Gold over Forest Green Putti Ikebana*
(with detail), 1991, 35 x 16 x 11 inches,
Gift of the family of Brian F. Dammeier

102 *Cadmium Red Venetian with Green Leaf*, 1991,
21 x 21 x 15 inches, Museum purchase

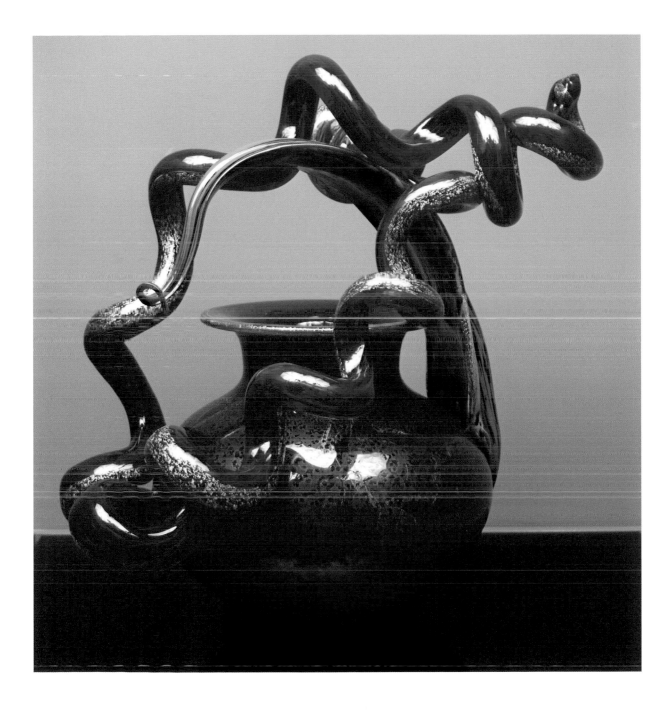

103 *Ma Chihuly's Floats* (with detail), 2006,
Gift of Dale, Leslie, and Jackson
Chihuly in honor of Viola Chihuly

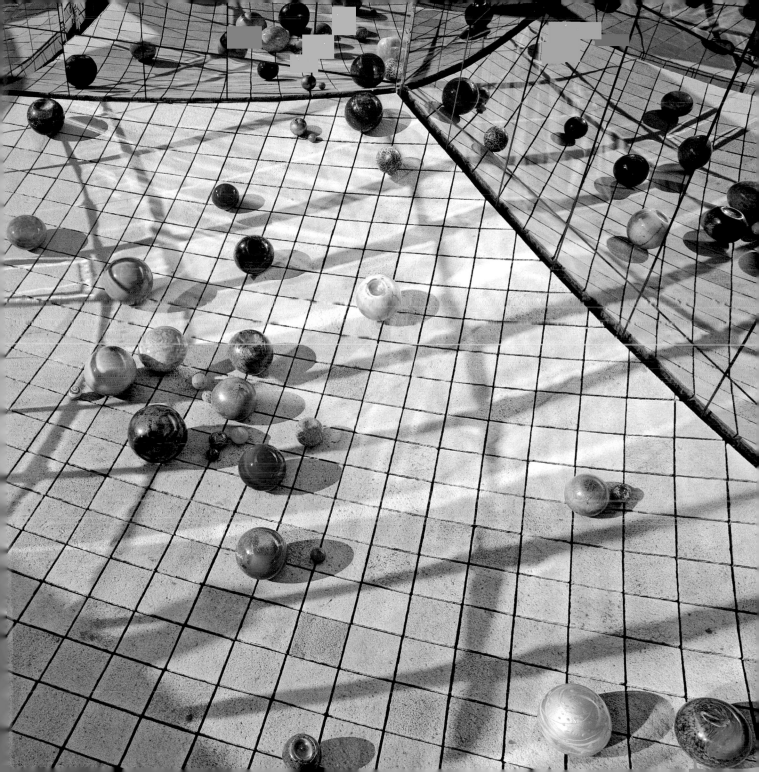

Note: Page numbers in *italics* refer to illustrations; captions are indexed as text. Artworks are by Dale Chihuly unless otherwise indicated.

EDITOR: Margaret L. Kaplan
DESIGNER: Russell Hassell
PRODUCTION MANAGER: Anet Sirna-Bruder

LIBRARY OF CONGRESS
CATALOGING-IN-PUBLICATION DATA

Hushka, Rock, 1966–
 Dale Chihuly : a celebration / Rock Hushka.
 p. cm.
 Catalog published to coincide with an exhibition held at the Tacoma Art Museum, Tacoma, Wash., May 21–Sept. 25, 2011.
 Includes index.
 ISBN 978-1-4197-0000-2 (alk. paper)
 1. Chihuly, Dale, 1941–Exhibitions. 2. Glass art—United States—Exhibitions. I. Chihuly, Dale, 1941– II. Tacoma Art Museum. III. Title. IV. Title: Celebration.
 NK5198.C43A4 2011
 748.092—dc22
 2010050326

Printed and bound in Hong Kong, China
10 9 8 7 6 5 4 3 2 1

Abrams books are available at special discounts when purchased in quantity for premiums and promotions as well as fundraising or educational use. Special editions can also be created to specification. For details, contact specialsales@abramsbooks.com or the address below.

ABRAMS
THE ART OF BOOKS SINCE 1949
115 West 18th Street
New York, NY 10011
www.abramsbooks.com

AUTHOR'S ACKNOWLEDGMENTS

Dale Chihuly: A Celebration honors Dale Chihuly on the occasion of his seventieth birthday. As is his tradition, Chihuly extended his generosity once again, which allowed this publication to grow into something far better than initially imagined. I wish to thank him for his interest in this project and his ongoing generosity to Tacoma Art Museum. The research and work for my essay offered an invaluable opportunity to understand more fully the importance of the Northwest to Chihuly's career and his contributions to the art of this region. Chihuly's innovations, aesthetic, and approach to collaborative art making have propelled not only the studio glass art movement worldwide but also have driven and reshaped the artistic community of the Northwest for nearly four decades. Without Chihuly, the Northwest would be a much less vibrant place in terms of art, beauty, and community.

I am grateful for the many individuals who helped shape this project. James Carpenter, Jack Lenor Larson, Flora C. Mace, Joey Kirkpatrick, and Patterson Sims generously shared their stories about Chihuly and their insights into his remarkable career. The project would not have been possible without the support and assistance provided by Chihuly Studio. I am grateful for the encouragement of Billy O'Neill, Britt Cornett, and Diane Caillier. The museum is indebted to the registration staff at the Chihuly Studio, especially Janná Giles and Ken Clark, for their assistance and expertise. In Tacoma, Ken Poyner, Washington State History Museum, and Robert Schuler, Tacoma Public Library, lent their assistance with archival photos. It was a great honor to work with editor Margaret L. Kaplan at Abrams and designer Russell Hassell, who created a superb book that conveys the spirit of Chihuly and the Northwest. Lastly, I wish to thank Dale again for all that he has given to Tacoma and Tacoma Art Museum.

Rock Hushka

PHOTOGRAPHY CREDITS

Tacoma Art Museum acknowledges the generosity of Chihuly Studios in granting access and giving permission to reproduce photography of Chihuly glass and personal collections. All images shown in this volume are copyright © Chihuly Studios, with the following exceptions:
© Tacoma Art Museum: 9, 12, 106–7
© Tacoma Public Library, Richards Studio Photography Collection: 14 (right column)
© Washington State Historical Society: 67
© 2011 Estate of Mark Tobey/Artists Rights Society (ARS), New York: 12

FRONT ENDPAPERS: *Soft Cylinders* (detail) The Boathouse, Seattle, 1992

VERSO: *Baskets Drawing* (detail), 1994, acrylic on paper, 60 x 40 inches

HALF TITLE: *Sky Blue Basket Set with Cobalt Lip Wraps* (detail), 1992, 17 x 15 x 16 inches

TITLE PAGE: *100,000 Pounds of Ice and Neon*, Tacoma Dome, 1993

PAGE 4: Dale Chihuly and Leslie Jackson Chihuly, Tacoma Studio One, 2010

PAGE 6: *Cobalt Violet Macchia with Cobalt Lip Wrap*, 1984. 7 x 18 x 8 inches. Tacoma Art Museum, Gift of the artist in honor of his parents, Viola and George, and his brother, George W. Chihuly

REAR ENDPAPERS: The Northwest Room, The Boathouse, Seattle, 1999

VERSO: Oregon City Woolen Mills, banded center-patterned shawl, tan fringe (detail), circa 1920

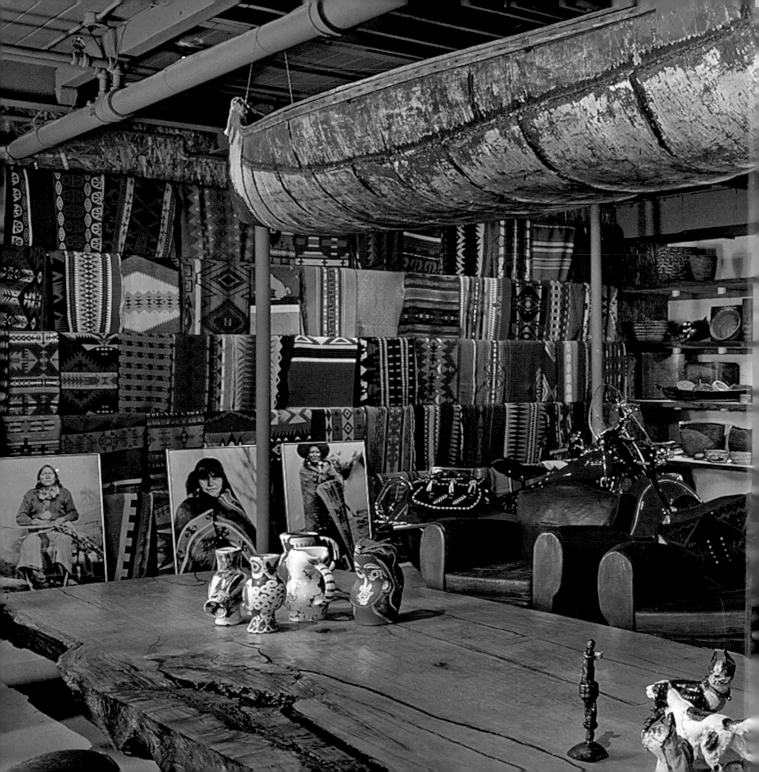